French Trademarks
The Art Deco Era

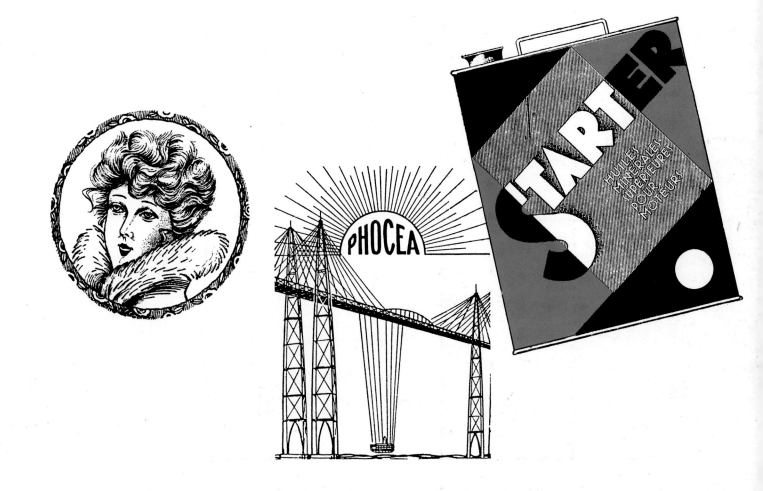

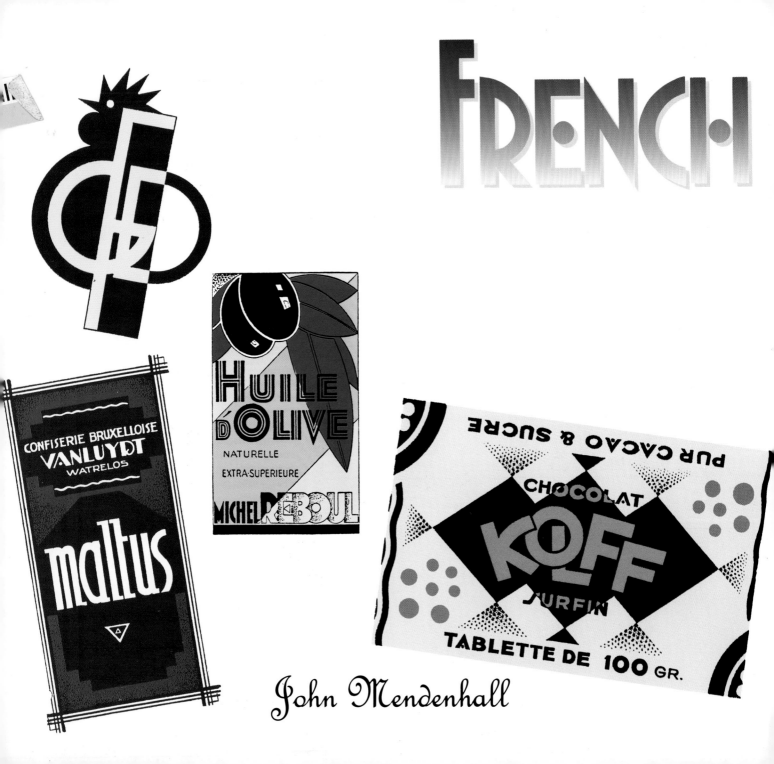

FRENCH

John Mendenhall

TRADEMARKS
The Art Deco Era

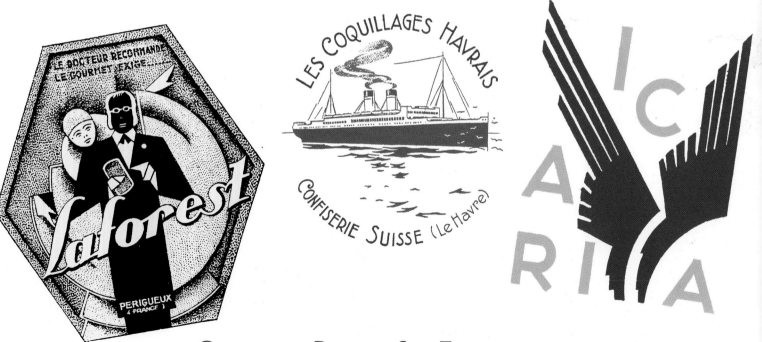

CHRONICLE BOOKS • SAN FRANCISCO

For Jerry Jankowski, a terrific designer and a friend.

Printed in Hong Kong.

Library of Congress Cataloging in Publication Data

Mendenhall, John. 1950-
 French trademarks : the Art Deco era / John Mendenhall.
 p. cm.
 Includes bibliographical references.
 ISBN 0-87701-853-7 :
 1. Trademarks--France. I. Title.
 T271.V2M46 1991
 929.9--dc20 91-9535
 CIP

Editing: Carolyn Miller
Book and cover design: John Mendenhall
Composition: Set in French Script and Sabon
by Magee Graphic Corporation, San Luis Obispo
Photography: Scott Loy, San Luis Obispo

Distributed in Canada by Raincoast Books,
112 East Third Avenue, Vancouver, B.C. V5T 1C8

10 9 8 7 6 5 4 3 2 1

Chronicle Books
275 Fifth Street
San Francisco, CA 94103

This book is a tribute to the many publicity designers and illustrators whose outstanding work has been hidden from public view for almost half a century. I would like to thank Brian Lane for his enthusiastic assistance in researching the trademarks, and Lisa Howard at Chronicle Books for her efforts in the realization of this project. Much appreciation goes to John and Connie Magee for their excellent job of typesetting, Carolyn Miller for the difficult task of editing the copy, and Ginger Moro, who provided the information on *pochoirs* for the Introduction as well as several plates from her collection. Very special thanks go to Nelly, at the Office of Industrial and Commercial Property in Paris, who provided help in translations for this non-French-speaking author.

All captions read left to right, top to bottom.
When two or more trademarks appear with a single
caption, all were issued by the same business.

Trademarks, Pages 2 and 3:

Light bulbs
SOCIÉTÉ LA COMPAGNIE DES LAMPES
PARIS • 1929

Shoes
ACHILLE HOCCART-LACOURTE
LILLE • 1931

Clothing
SOCIÉTÉ L. ANGELI ET CIE
MARSEILLE • 1933

Automotive oil
GROUPEMENT DES GARAGISTES
MÉCANICIENS
VINCENNES • 1932

Bonbons
JOSEPH VANLUYDT
WATRELOS • 1935

Olive oil
ADOLPHE PUGET
MARSEILLE • 1932

Chocolates
VINCENT MOMPO
NÎMES • 1933

Canned foods
SOCIÉTÉ DE CONSERVERIES
FINES DU PÉRIGORD
PÉRIGUEX • 1932

Pastries & confections
ADRIENNE AND HÉLÈNE CERTAIN
LE HAVRE • 1931

Silk fabrics
SOCIÉTÉ INDUSTRIELLE DE MOY
PARIS • 1930

Pages 4 and 5:

Threads & fabrics
SOCIÉTÉ ANONYME DES TISSAGES
GUERRY-DUPERAY
ROANNE • 1931

Table of Contents

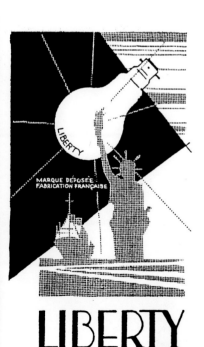

∧ Cotton fabrics
Société Anonyme Union Textile
Guebwiller • 1934

< Light bulbs
Société Anonyme l'Orfèvrerie Liberty
Sable-sur-Sarthe • 1930

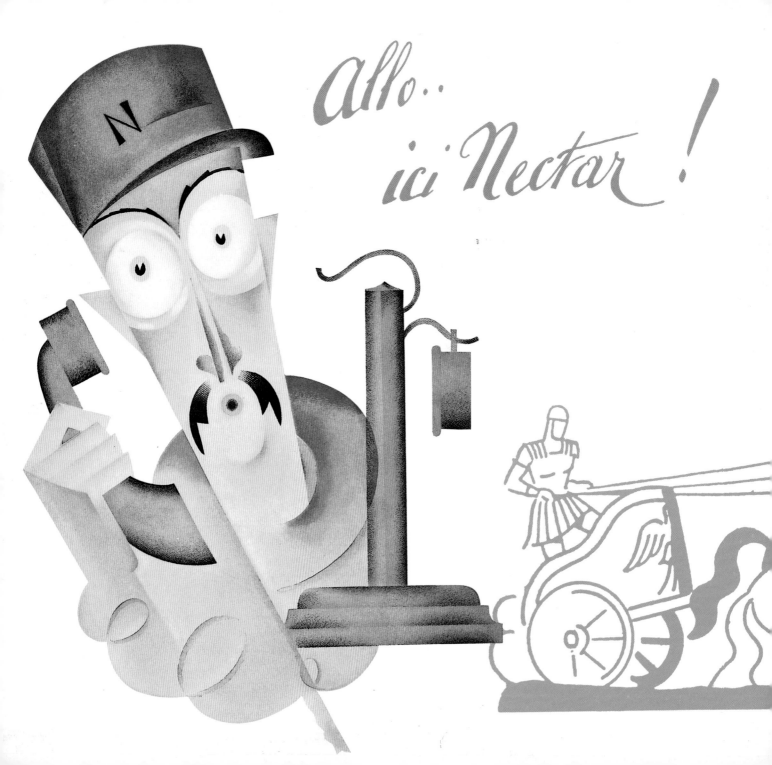

Introduction

Wandering the narrow streets of the Marais district in Paris, you can still see glimpses of the city as it was between the two world wars. On every block there is a reminder of the halcyon days of the past. On one corner a pâtisserie glows warmly, its shelves abundantly stocked with fresh baked goods. Amazingly, the storefront with its decorative 1920s signs remains virtually unchanged. Across the way, on a brick wall two flights up, a crumbling poster advertises a long-forgotten clothing store, its illustration of dapper gentlemen faded by time. Throughout the Marais and the other arrondissements of Paris are small reminders of the glories of another era, when the City of Light seemed to be at the epicenter of a cultural explosion.

After the trauma of World War I a new prosperity developed during the decade of the 1920s. The boom in the French economy was paralleled throughout Europe and America. Industry flourished, no longer encumbered by the war effort. The mood of negativism that had been brought on by years of death and destruction seemed to evaporate as society embraced the pleasures of life.

Writers, artists, poets, and philosophers descended upon Paris for two decades of creative endeavor and good-natured debauchery. A strong dollar opened the way for an invasion of Americans. Tourist-class passage across the Atlantic Ocean cost as little as eighty dollars; a relatively small amount of cash would subsidize an American for years. The openness of the city attracted such great authors as F. Scott Fitzgerald, Ernest Hemingway, and James Joyce, who made an indelible stamp on the intellectual life of Paris.

Artists gravitated towards the Montparnasse section of the city with its ample supply of inexpensive studio space. Pablo Picasso established a studio there, as did Marcel Duchamp, who returned to Paris from the United States in 1919. While Picasso expanded on the tradition of Cubism, which he had helped develop prior to the war, Duchamp became involved in the Dadaist Movement. Its embrace of the irrational and shocking was indicative of the "anything goes" mood of the times. In 1925 Duchamp joined Salvador Dali in the Surrealist Movement, which produced art based on dreams and the subconscious.

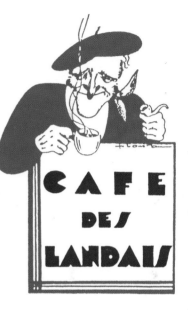

This 1933 trademark for a café in Mont-de-Marsan caricatures the typical French patron of the era.

A dramatically stylized chariot and horses were utilized in this 1930 symbol for an unidentified agricultural producer.

Cafés reigned as meeting places for painters, writers, and the many others who were involved in the arts. Politics was the incessant topic of discussion among the intelligentsia, many of whom would argue into the evening in the city's numerous bistros. Nightlife blossomed during the 1920s. Dancing had been discouraged as a frivolity by the government during the war, but as a new hedonism permeated French society, countless bars and dives and pleasure houses serviced the desires of free-thinking individuals. Jazz, imported from the United States, was popularized across France. Cabarets that stayed open until dawn were the rage in this era of excess.

Against this backdrop of pleasure and prosperity the commercial arts flourished. Businesses of all sizes were anxious to tap into the overindulgence of this gilded age. Free-spenders were bombarded with advertising promoting products of all kinds. In an era of rampant consumerism, stylish images conveyed the enthusiasm of the times.

Hundreds of commercial artists worked throughout France in relative obscurity, overshadowed by the stars of the profession who had studios in the major cities of Paris, Lyon, or Marseille. Many of these *publicité* designers had received training in the decorative arts, an offshoot of the traditional fine arts programs offered at schools such as the École Nationale des Beaux Arts. Formal education in specialized fields such as illustration and bookbinding was firmly established in France by 1925.

As is true today, graphic designers relied on a variety of projects to produce income. Because of their size and visual impact, posters are the most memorable contributions of these talented individuals. But it was the small jobs that supported the designer between poster commissions. The majority worked in advertising, layout, trademark and sign design; some acquired accounts in label, packaging, and book design.

A number of poster artists turned their creations into trademarks for their client's businesses. The poster images that A.M. Cassandre created for Dubonnet aperitif and Leroy Opticians were also registered *(marque déposée)* with the French Office of Industrial and Commercial Property. It is a testament to Cassandre's skill that these memorable designs were stylish enough to work equally well on the large scale of a poster and the much smaller size of a trademark.

Strongly influenced by Cubist painters, Cassandre perfected a method of illustration based on geometry and simplified forms. He used this

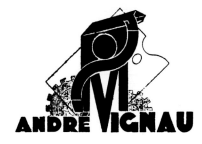

Identity for André Vignau. Like many French trademarks, this design for a printer of advertising and posters integrates typography with the image.

Even the representation of such a lowly product as a bedspring is given artistic flair in this 1933 symbol for Tréfilerie Moderne of Paris.

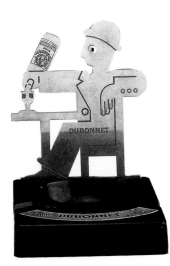

A.M. Cassandre's design for the Dubonnet Man was adapted to a variety of uses, including this stainless steel and bakelite ashtray.

reductionist approach to design in creating the "Dubonnet Man," a comical figure that could be manipulated into a variety of poses for various advertising purposes. His logo for Leroy Opticians features the head of a young man with all detail in silhouette except for the eyes and eyeglasses, thus emphasizing the product.

Advertising designers Léon Dupin and Leonetto Cappiello also created trademarks. As was common practice, they discreetly signed their creations. Apparently because clients hired well-known artists at a certain expense, businessmen were not adverse to having their marks carry a signature of distinction.

Many designers and illustrators of the era utilized the *pochoir* process, a hand-colored stenciling technique, in their work. A stencil *(pochoir)* was cut for each color in an image, then watercolor or gouache was carefully applied with a brush or sponge. The result was a sensual, smoothly layered design with the look and feel of velvet. In trademarks where a flat graphic effect or gradation was required, the *pochoir* process was utilized for the creation of the original artwork.

The French couturier Paul Poiret started the *pochoir* vogue in 1908 with a privately published album of his haute couture fashion, as interpreted by Paul Iribe. Other artists of the period, including George Barbier, Umberto Brunelleschi, and Charles Martin, contributed luscious *pochoirs* to the fashion magazines *Gazette du Bon Ton* and *La Guirlande*.

Between 1908 and 1935 the *pochoir* flourished; the technique was used in advertisements, theater programs, label designs, and postcards. Major poster artists like Jean Carlu and Paul Colin utilized *pochoirs* in their work. Because the original art for trademarks no longer exists, it is generally difficult to discern from printed reproductions whether they were *pochoirs* or pen and ink renderings.

Regardless of the method used to create the image, what differentiates French trademarks of this remarkable age from their European counterparts is the artistic flair that is part of each design. Like posters from the same period, French Art Deco logos are dramatic and eye-catching. The instant appeal of these fascinating symbols attests to the impressive talent and proficiency of their designers.

This sophistication did not surface until immediately after World War I, coinciding with the development of a new style of design now referred to as Art Deco. The florid, organic Art Nouveau, popular before the war, was

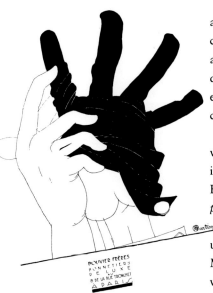

George Martin utilized the *pochoir* process in his identity for Bouvier Frères Bonnetiers De Luxe, a Parisian hosiery merchant.

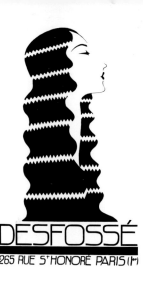

The *pochoir,* or stencil, was ideally suited to advertising and poster illustration, as well as for trademarks in which a flat graphic effect was desired.

viewed with disdain by post-war French designers, who were seeking a style that more appropriately reflected the age. Art Deco formally debuted at the 1925 Exposition Internationales des Arts Decoratifs et Industriels Modernes in Paris, where pavilions of the large Paris department stores displayed handcrafted products from the country's top designers.

Furniture, glass, ceramics, and fashion designs were featured as works of art. Decorative and garish, most of it was meant for purchase by wealthy people seeking what was considered the most innovative design available. Drawing its inspiration from a myriad of sources, including the geometry of Cubism, the ornamental excesses of French Rococo, the angularity of the machine aesthetic, and the overt luxury of haute couture, Art Deco fed on the public's demand for the *au courant*. Avant-garde architect and furniture designer LeCorbusier summed up the impact of the Paris exposition when he wrote: "1925 marks the decisive turning point in the quarrel between the old and the new."

As a style of ornament, Art Deco was applied with subtlety or flamboyance, depending on the temperament of the designer. Because it was derived from a hodgepodge of different styles it evades a narrow definition. Yet in the graphic arts, such as trademark design, Art Deco was distilled into a purer form, less a pastiche than a method of heightening communication between merchant and consumer.

The beauty of Art Deco as translated onto the printed page was its use of geometry as the underlying structure for illustration. The simplification of complex forms, such as the human figure, into basic shapes allowed for the depiction of objects with a sparsity of linework. Superfluous details were eliminated, resulting in bold, dramatic images.

Typography was stripped of its decorative serifs, as blockier geometric typefaces were ideally suited to the angularity of the imagery. The decorative flourishes of Art Nouveau lettering gave way to simpler type based on the circle, square, and triangle. Designers' preference for angular typography grew steadily in the latter 1920s and reached its peak in the middle 1930s. Typefaces such as Futura and Bernhard Gothic came to be associated with the Art Deco style.

Dynamic compositions were commonly employed in graphic design as increasing amounts of advertising competed for the viewer's attention. Dramatic perspectives, such as the aerial view or the ground-to-sky angle, were used with equal effectiveness on posters as well as trademarks. The

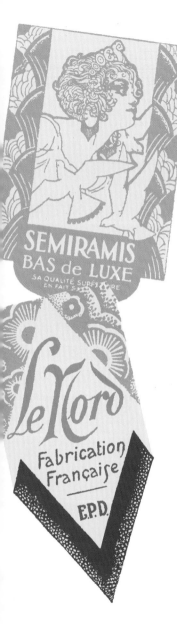

The flamboyant style of the early 1920s was ideally suited to these hosiery labels, which were also registered as trademarks.

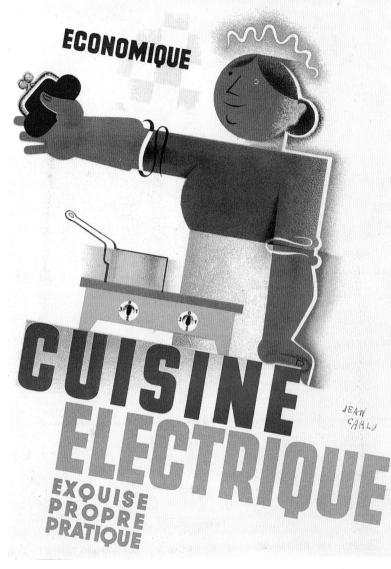

ECONOMIQUE

CUISINE
ELECTRIQUE

EXQUISE
PROPRE
PRATIQUE

JEAN CARLU

Jean Carlu poster design for
Cuisine Electrique. The image
of the cost-efficient cook was
simplified in black and white
for use as a trademark.

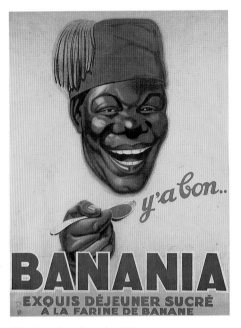

y'a bon..

BANANIA
EXQUIS DÉJEUNER SUCRÉ
A LA FARINE DE BANANE

Ubiquitous throughout the 1920s
and 1930s was the trade character
of the Banania Man.

By 1925 most trademark designers
preferred the Cubist-inspired
geometry of the machine aesthetic.
The 1930 trademark for Pathé-
Cinéma features a dramatically
simplified rooster and a sans serif
typeface.

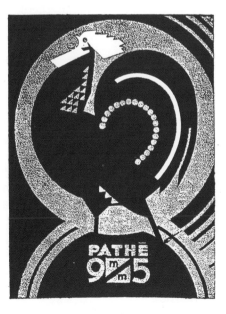

PATHÉ
9m/m5

implied motion of a car racing across a rural landscape or a group of figures parading into the space of a poster or logo suggests a cinematic approach to design: a moment of action frozen as in a clip from a motion picture.

The subject matter of Art Deco graphics, and trademarks in particular, reflects the upbeat mood of the times. After World War I the French loved to travel, so many trade symbols of this era capture the feeling of a society on the move. Railroad and ocean liner holidays increased substantially throughout the 1920s, while the sale of motorcars gained considerably. By 1930 airplane travel had come into vogue as more wealth allowed for greater mobility overseas. It became common for companies not even remotely associated with transportation to use images of planes, ships, and locomotives to establish their identity.

With society obsessed with nightlife it made perfect sense to feature elegantly attired ladies and gentlemen in trademarks. This was particularly true for clothing manufacturers, but such symbols were also popular among perfume and pharmaceutical companies.

The most common subject of trademarks, however, was the depiction of people at work or play. What more appropriate way to symbolize a bootmaker or baker than with a picture of the individual involved in his trade? A popular image of the era was the caricature of Nectar, created in 1921 as the logo for the wine merchant Nicolas. The wide-eyed character carrying wine bottles in his hands (*vin blanc* in his right, *vin rouge* in his left) was based on an actual deliveryman who was well known in the streets of Paris. Although A.M. Cassandre and other poster artists immortalized him, the version drawn by the designer Dransy is the one that was registered as a trademark. A child companion to Nectar was introduced in 1922. Similarly wide-eyed and pigeon-toed, the figure of Glou-Glou was used for fifty years until an anti-alcohol campaign forced him to be retired.

Blacks were used in trademarks, as there was great fascination among the French with *lé bon négre*. Expeditions and colonialism around the turn of the century heightened the awareness of Africa and the Black race. Poster designers would frequently use the image of a Black person when exotic products were being advertised. Imported coffee, rum, and food products were sold throughout the 1920s and 1930s with Black caricatures; unflattering and exaggerated facial features played into the racist tendencies of the times.

One of the great classic French trademarks is the Banania Man, a jovial

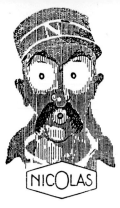

Nectar, the character mark for Nicolas wine merchants, was depicted by a variety of artists throughout the 1930s.

All modes of transportation were used as images in trade symbols, including this 1937 design featuring a hydroplane landing at a faraway port.

GLOU-GLOU
Fils de Nectar

Black man in a red fez who has been used to promote a banana-flavored beverage since 1917. The trademarked image, with the quote "*y'a bon,*" has adorned posters, signs, and product tins for more than half a century. As public attitudes towards race have changed, so also has the Banania Man: Over the years he has been gradually abstracted to the point of unrecognizability.

Perhaps the most widely known French trademark is Bibendum, introduced in 1895 by the Michelin Tire & Rubber Company. Although the jolly character, whose figure is based on a stack of automobile tires, was designed before the 1920s, he was popularized during that decade; tire sales soared concurrently with the sale of motorcars. Bibendum's rotund form was translated into a wide variety of promotional material, ranging from ashtrays to three-dimensional mascots mounted on delivery vans. He is one of the few trademarks from the 1920s and 1930s to still remain in use today.

It is apparent that many trademark designers and their clients had a good sense of humor, as an appreciable number of symbols from this era exhibit a refreshing bit of tongue-in-cheek wit. A logo for a radio vacuum tube manufacturer features three tubes, two of which are wearing miniature caps. The trademark for a champagne producer is a bottle (with wings and a propeller) taking off into the sky. These visual puns delight the eye and add to the humanity of the symbols.

LES GARS DE LA RADIO

The 1933 trademark for La Radiotechnique, a Paris radio tube manufacturer.

Although French advertising design flourished throughout the 1920s, by the early 1930s worldwide economic depression began to affect France as it did other nations. The free-spending habits of a hedonist decade were replaced by austerity as business contracted. The joy and panache seen in trademark designs gradually dissipated as hard times enveloped the nation. By 1935 Art Deco had fallen into disfavor; few trademarks of note were being produced.

The mood in France was further dampened as the Third Reich gained power in Germany. France was invaded by Hitler's army in 1940. The Fall of Paris brought an end to decades of French superiority in the graphic arts.

After World War II Switzerland became a major influence in graphic design, while commercial art blossomed in America. Unfortunately, France was never able to regain the status she once held during the Art Deco era. The trademarks in this collection are reminders of that period of creative vitality between the wars. Many are masterpieces of design that affirm the value of the human spirit—and hand—in the design process.

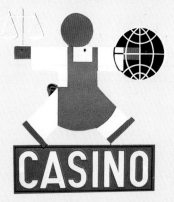

CASINO

Grocery stores
Société des Magasins du Casino
St-Etienne • 1930
Design: A.M. Cassandre

Food AND FINE COOKING HAVE LONG BEEN ASSOCIATED WITH THE FRENCH PEOPLE, WHO OVER THE YEARS HAVE BECOME MASTERS OF THE CULINARY ARTS. DURING THE 1920S THE PLEASURES OF DINING APPEALED TO THE NEW WEALTHY MIDDLE CLASS. HOME ENTERTAINING BECAME WIDELY POPULAR AS RESIDENCES BEGAN TO COMBINE LIVING AND DINING ROOMS INTO ONE LARGE SPACE, ACKNOWLEDGING THE IMPORTANCE OF EATING AND SOCIALIZING AS COMPLEMENTARY ACTIVITIES. COOKS SHOPPED FOR MEALS IN SMALL GROCERY STORES OR SPECIALTY SHOPS. CHAINS SUCH AS MAGGI AND CASINO OPENED THROUGHOUT THE COUNTRY, SELLING AN ASSORTMENT OF *PRODUITS ALIMENTAIRES*. BOULANGERIES PROVIDED THE FRENCH STAPLE OF BREAD, WHILE PÂTISSERIES FEATURED DELIGHTFUL ARRAYS OF DESSERT TREATS. THE TRADEMARKS OF FOOD PRODUCERS, SHOPS, AND EVEN PRODUCT LABELS CONVEY A SENSE OF THE GOOD LIFE, OUTNUMBERING SYMBOLS OF OTHER TYPES OF BUSINESSES DURING THIS ERA OF CONTENTMENT.

Food products
Société Anonyme des Docks du Rhône
Tarascon • 1932

Pastries >
Pierre Asselin
Pantin • 1930

Grocery stores
Société Economique de Rennes
Rennes • 1930

< Canned Foods
ROLAND LENAIRE
CATTENIÉRES • 1930

Confections
SOCIÉTÉ ANONYME SUCRERIE BOURGUIGNONNE
ET CHOCOLATERIE A. LANVIN RÉUNIES
BRAZEY-EN-PLAINE • 1931

^ Confections
GABRIEL DROUILLAND
FONTENAY-LE-COMTE • 1930

Page 19

Canned ham
SOCIÉTÉ ANONYME: ETABLISSEMENTS
BERNARD FASSONE
CANNES • 1933

Canned foods
GEORGES EGLEM
FOURMIES • 1932

Canned mushrooms >
ETABLISSEMENTS DERUNGS ET CIE
SAINT-OUEN-L'AUMÔNE • 1933

Pasta
SOCIÉTÉ PREFERITA D'ARTIX
ARTIX • 1932

Jambon de régime "MAJESTIC"

CHAMPIGNONS DE PARIS

MARQUE DÉPOSÉE

MARQUE DÉPOSÉE

LA FOURMI DU NORD

MILANO

Soups
CHARLES MERCIER
LONS-LE-SAUNIER • 1933

Canned foods
PIERRE, MARIE, JOSEPH, & CHARLES TEYSSONNEAU
BORDEAUX • 1930

LES DEUX GOURMANDS

Chocolates
LEBLANC ET DAVID FRÉRES
VIRE • 1931

LE
CHAT
GOURMET

Pastries
SOCIÉTÉ MARTIN ET CIE
PARIS • 1932

Food products
MAISON AMIEUX FRÈRES
NANTES-CHANTENAY • 1932

LE PINGOUIN JOYEUX

GUYANDRÉ

SARDINES PORTUGAISES A L'HUILE D'OLIVE

filets de Morue sans arêtes

"ARTIK"

MARQUE DÉPOSÉE

COVIGA

Les Trois Poissons

MARQUE DÉPOSÈE

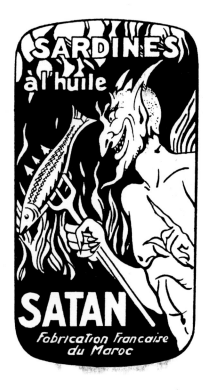

SARDINES à l'huile

SATAN

Fabrication Française du Maroc

< *Canned sardines*
JEAN-BAPTISTE PIERREPONT
LA MADELEINE • 1931

Grains & sugar
VICTOR GAUVAN
DAKAR • 1932

∧ *Canned codfish*
GABRIEL & GUSTAVE CAPELLE
BÈGLES • 1930

Canned sardines
PIERRE SCHANG
PONT-CROIX • 1934

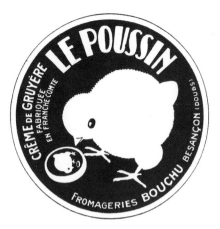

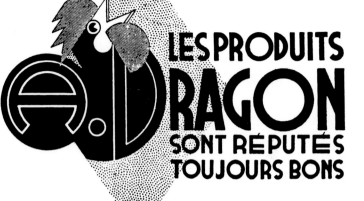

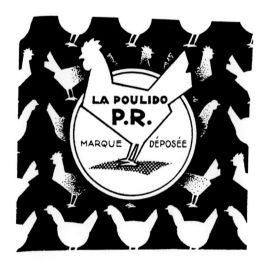

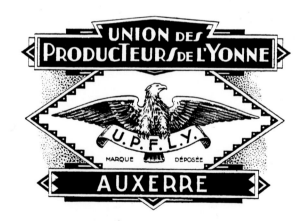

Cream of Gruyère
CHARLES BOUCHU
BESANÇON • 1930

Eggs
PIERRE & FERNAND RIGAUT
NICE • 1932

Canned foods
ADOLPHE DRAGON
MARSEILLE • 1936

Canned foods
SOCIÉTÉ ANONYME L'UNION DES PRODUCTEURS
DE FRUITS ET LÉGUMES DE L'YONNE
AUXERRE • 1931

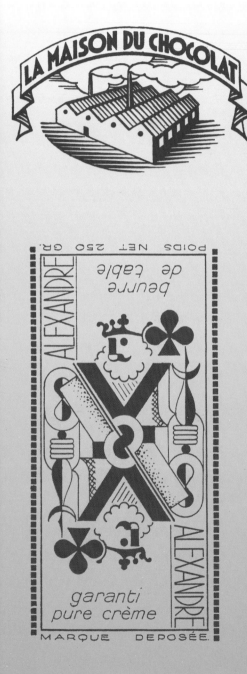

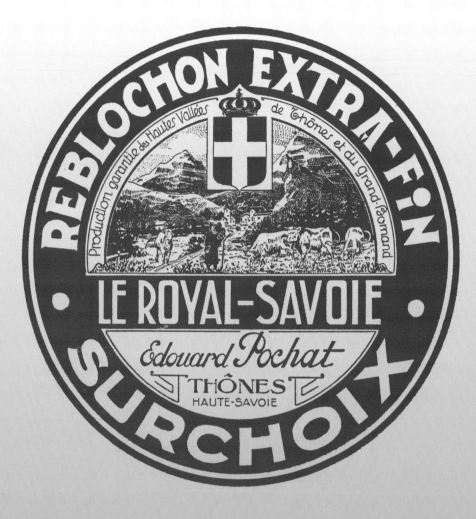

< Chocolates
SOCIÉTÉ HAKI ET CO
PARIS • 1930

Butter
MAURICE ALEXANDRE
MAYENNE • 1930

^ Cheeses
EDOUARD POCHAT-COTILLOUX
THÔNES • 1933

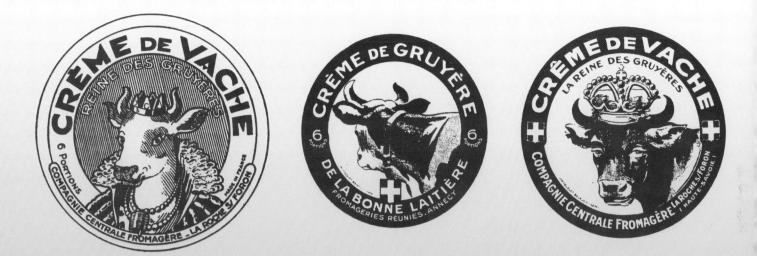

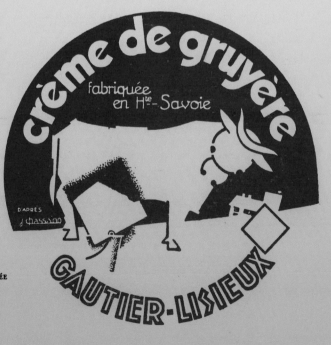

^ Cheeses
COMPAGNIE CENTRALE FROMAGÈRE
LA ROCHE-SUR-FORON • 1930

Cheeses
LOUIS BOUCHET
ANNECY • 1930

Cheeses
COMPAGNIE CENTRALE FROMAGÈRE
LA ROCHE-SUR-FORON • 1929

Cheeses >
SOCIÉTÉ À RESPONSABILITÉ LIMITÉE
DES ETABLISSEMENTS GAUTIER
LISIEUX • 1933
DESIGN: J. CHASSAING

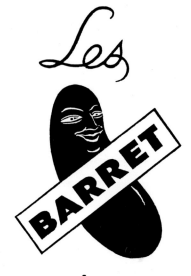

Les **BARRET** *sont exquis*

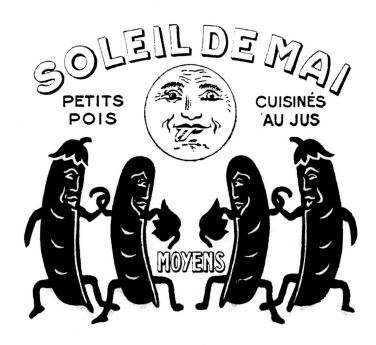

SOLEIL DE MAI

PETITS POIS

CUISINÉS AU JUS

MOYENS

Dried beans

ADONIS BARRET

MEUNG-SUR-LOIRE • 1930

Canned vegetables

HENRI MARTEL

MARSEILLE • 1932

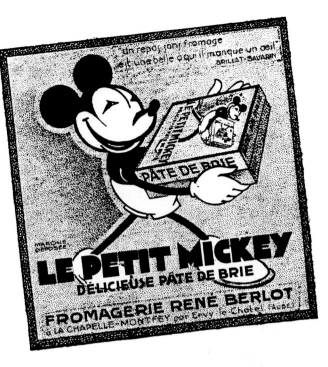

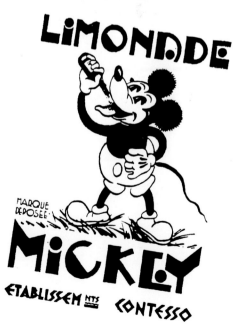

∧ Cheeses & butter
JEAN DANSARD
PARIS • 1931

Cheeses
RENÉ BERLOT
ERVY-LE-CHATEL • 1933

Lemonade >
AUGUSTE, JOSEPH, & ISIDORE CONTESSO
ANTIBES • 1932

SAINT-URBAIN
THE
C EST LA SANTE

^ Teas
EMILE HOLLENDER
SARREGUEMINES • 1932

THÉ
REYMAN'S

TISANE DE
Ste THÉRÈSE

Teas
ETABLISSEMENTS REYNAUD-GEILINGER
MARSEILLE • 1934

Teas
LOUIS DÉSIRÉ, & JOSEPH DÉRUELLE
BEUZEVILLE • 1930

Teas
GASTON SEBAN
ALGER • 1933

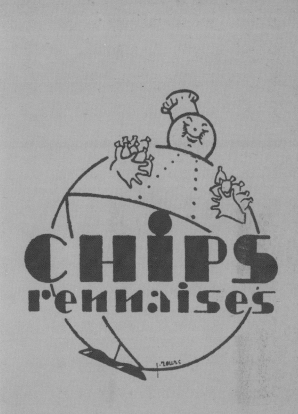

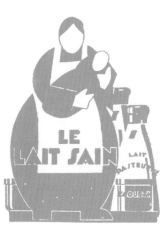

Fruits >
SOCIÉTÉ À RESPONSABILITÉ
LIMITÉE BONVILLE
CANNES • 1932

Food products
BOUCHERON-SEGUIN
LE HAVRE • 1929

Dairy products
JEAN MANENT
ALGER • 1933

^ *Vegetables*
ALFRED BARON
RENNES • 1932

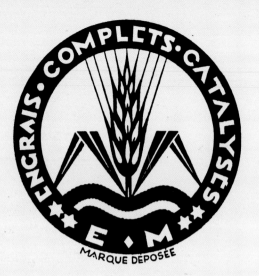

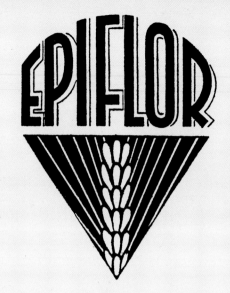

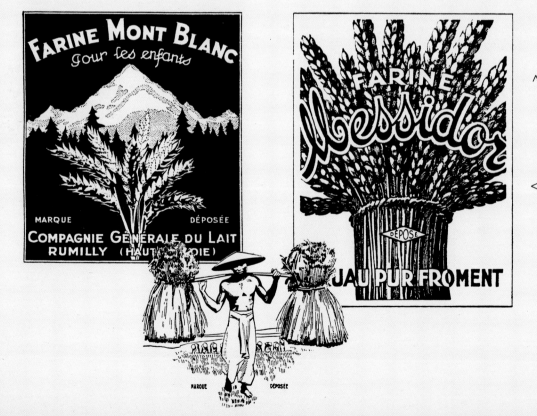

^ *Chemical fertilizers*
EMILE & FRÉDÉRIC MATHIOT
SAINT-HILAIRE-CHALO • 1929

Flour
PIERRE GARNERO
NIMES • 1931

< *Flour*
SOCIÉTÉ: COMPAGNIE GÉNÉRALE DU LAIT
RUMILLY • 1933

Agricultural products
COMPAGNIE DE COMMERCE ET DE NAVIGATION
D'EXTRÊME-ORIENT
PARIS • 1931

Flour
SOCIÉTÉ À RESPONSABILITÉ LIMITÉE:
VEUVE DUBOIS ET FILS
BERSÉE • 1933

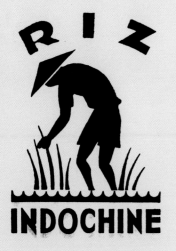

Rice

Syndicat des Exportateurs Français
de Riz de Saïgon
Paris • 1931

Flour

Grands Moulins de Paris
Paris • 1933

Agricultural products

Société Anonyme des Galeries Lafayette
Paris • 1934

^ Confections & pastries
RENÉ, JEAN, AND JOSEPH ERRE
AVIGNON • 1933

Confections >
MIREILLE PAULET
MARSEILLE • 1930

Lemon soda
VICTOR CATTEAU
DOUAI • 1932

Confections counter display >
PIERROT GOURMAND
BRETENOUX-BIARS • c. 1930

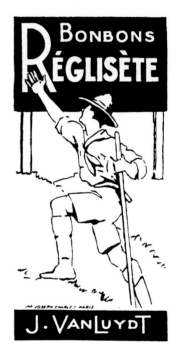

Baking powder
HENRI AND CHARLES BRETTEVILLE
LISIEUX • 1933

Cheeses
SOCIÉTÉ ANONYME AUER
WISSEMBOURG • 1931

Bonbons
JOSEPH VANLUYDT
WATTRELOS • 1931

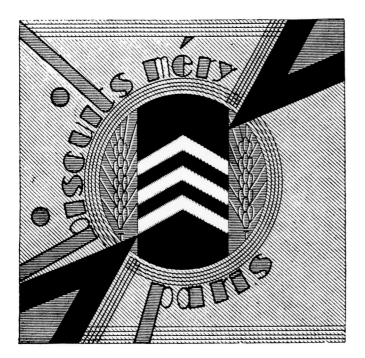

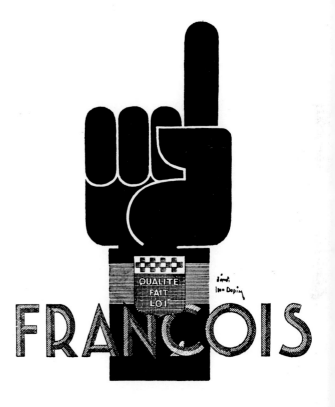

Cookies

Eugène Méry

Paris • 1930

Grocery stores

Société: Etablissements Pierre François

Paris • 1933

Design: Léon Dupin

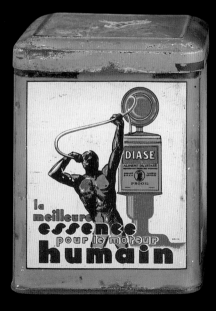

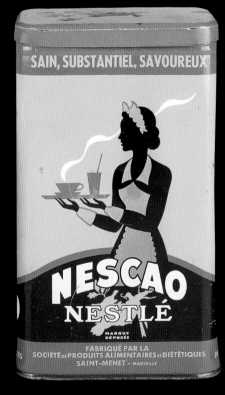

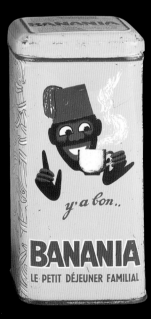

Chocolates & cocoas

Francine Soule
Orthez • 1932

Cocoa

Marc & Pierre Nebout
Bordeaux • 1932

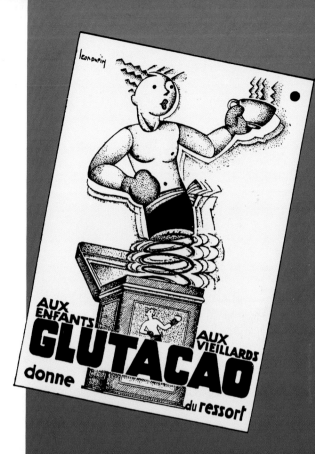

∧ Cocoa
Joachim Saveret
Chalon-sur-Saône • 1930
Design: Léon Dupin

∧ Charcuterie & canned foods
EUGÈNE ROESS
ANDOLSHEIM • 1933
DESIGN: LÉON DUPIN

Grocery stores ∧
SOCIÉTÉ ANONYME DES GRANDS ECONOMATS PARISIENS
LA PLAINE-SAINT-DENIS • 1931

Grocery
SOCIÉTÉ ANONYME: LA MAISON DU CAFÉ
TOULOUSE • 1933

Grocery stores >
ETABLISSEMENTS PERNET
TOULON • 1932

YOU-YOU
DESSERT AU JUS DE RAISIN

"yoyo Soda"

ECOBANA
PETIT DÉJEUNER SUCRÉ DU MATIN

Preserves
HYACINTHE LORIN
MESSAC • 1932
DESIGN: LÉON DUPIN

Sodas & mineral water
COMPAGNIE FRANÇAISE DES BOISSONS HYGIÉNIQUES
MARSEILLE • 1930

Breakfast foods
ETABLISSEMENTS MIELLE ET CIE
CHÂLONS-SUR-MARNE • 1933

Chocolates >
PRIMAX
PARIS • 1932

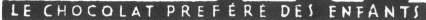

LE CHOCOLAT PRÉFÉRÉ DES ENFANTS

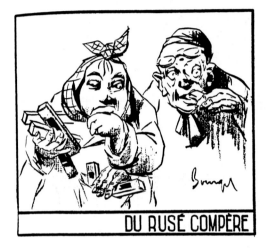

DU RUSÉ COMPÈRE

A fin gourmet...conserves Vernet

VERNET FRÈRES
ORLÉANS

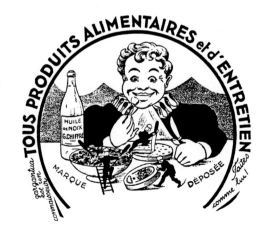

TOUS PRODUITS ALIMENTAIRES et d'ENTRETIEN

MARQUE

DÉPOSÉE

∧ *Pastries & confections*
RENÉ DENECÉ
PARIS • 1931

Canned foods
ETABLISSEMENTS VERNET FRÈRES
ORLÉANS • 1933

< *Food products*
ETABLISSEMENTS G. CHIFFRE
SAINTE-MAURE-DE-TOURAINE • 1933

Fertilizers
SOCIÉTÉ DES SUCRERIES ET DISTILLERIES
DU SOISSONNAIS
SOISSONS • 1933

Confections
RENÉ RETARD
NANTES • 1931

Butter & cheese
GABRIEL PRÉVOT
COMPIÈGNE • 1929

^ Canned foods
ERNEST BERNE
SAINT-CLAUDE • 1931

< Canned vegetables
FÉLIX LE BIHAN
MORLAIX • 1932

Food products
SOCIÉTÉ ÉTABLISSEMENTS REYNAUD DE MAZAN
MARSEILLE • 1929

Canned foods
ROGER ADAM
MARSEILLE • 1932

MARQUE DÉPOSÉE

MARQUE DÉPOSÉE SYLVAIN GUICHARD

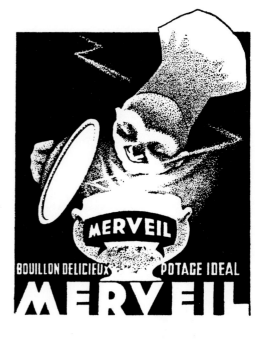

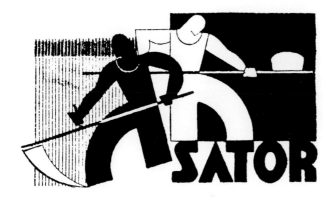

∧ *Bouillon*
PRODUITS ALIMENTAIRES BORG ET CIE
SCHILTIGHEIM-STRASBOURG • 1934

< *Pasta*
SOCIÉTÉ ANONYME SODEXANE D'EXPANSION
DES APPLICATIONS NOUVELLES
STRASBOURG • 1933

Canned foods
GUY MOREL
PARIS • 1930
DESIGN: SYLVAIN GUICHARD

Baked goods & pastas
SANFARINE
PARIS • 1931

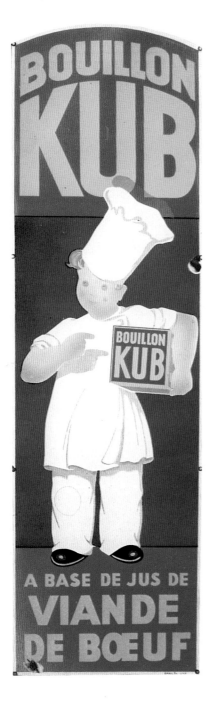

< Canned foods
SOCIÉTÉ ETABLISSEMENTS ALOT DEBRECK
LE HAVRE • 1938

Fresh meats
SOCIÉTÉ DES PRODUITS D'ALIMENTATION
PARIS • 1934

Cardboard easel advertising sign >
for Rita gingerbread
PRODUITS RITA
ROUBAIX • C. 1930
DESIGN: LÉON DUPIN

< Bouillon cubes
JULES MAGGI
BORDEAUX • 1920

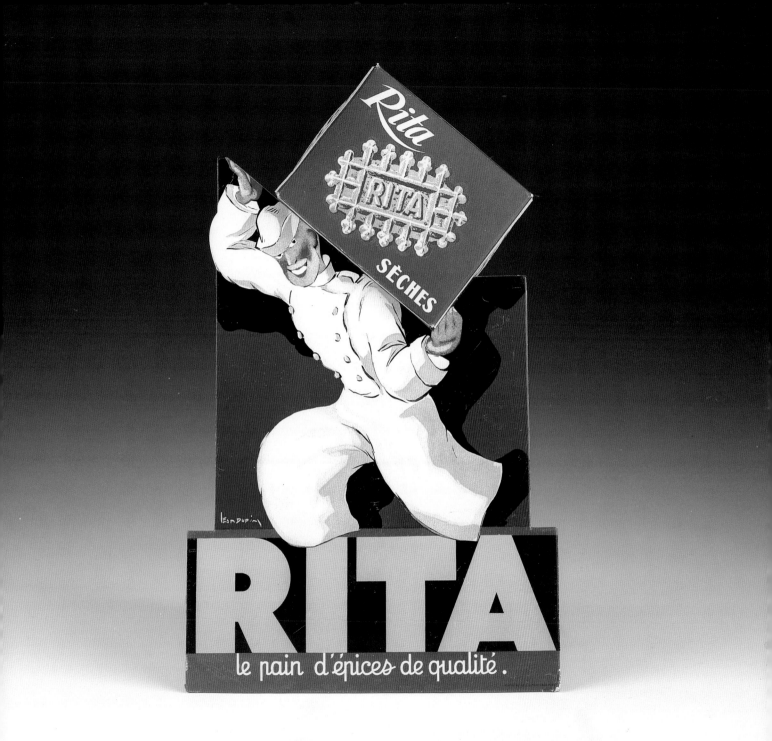

PRIMÉTOILE
· LE CINÉMA GRATUIT ·

1933

MARQUE DÉPOSÉE

Pastries
LOUIS ANGLADE
PARIS • 1933

CO OP TAHITI

"INDIANA"

∧ Pastries & confections
LUGAND ET PRUNGNAUD
POITIERS • 1933

Agricultural products
COMPAGNIE OCÉANNE DES PRODUITS COLONIAUX
GENTILLY • 1930

Food products
SOCIÉTÉ TOULOUSAINE DES CAFÉS PRIMES
TOULOUSE • 1932

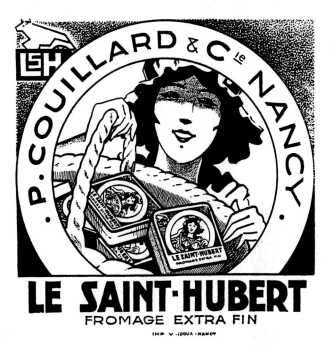

Cheeses
SOCIÉTÉ PAUL COULLARD ET CIE
NANCY • 1933

Flours
SOCIÉTÉ FILS DE FORTUNÉ LOMBARD
MARSEILLE • 1932

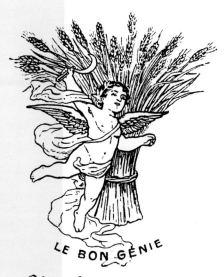

Olive oils
DANIEL BOYER
PEYNIER • 1934

Wines
VINS DU POSTILLON
STRASBOURG • C. 1930

Wine and spirits WERE THE SOCIAL LUBRI-CANTS OF FRENCH SOCIAL LIFE DURING THE AGE OF SELF-INDULGENCE. COCKTAILS REPLACED TEA AT FIVE O'CLOCK; MUSIC HALLS SUCH AS THE FOLIE-BERGÈRE AND MOULIN ROUGE IN PARIS WERE IMMENSELY POPULAR. THE QUALITY OF FRENCH WINES WAS UNSURPASSED. MANY VINTNERS REGISTERED THEIR LABELS AS TRADEMARKS TO PREVENT COPYING BY RIVALS. SALES OF DUBONNET SOARED AS A.M. CASSANDRE'S PUBLICITY DESIGNS FOR THE APERITIF GAINED WIDESPREAD ATTENTION. GLAZED PORCELAIN SIGNS FEATURING THE SYMBOLS OF WINE PRODUCERS AND BREWERS WERE DISTRIBUTED TO RETAIL ESTABLISHMENTS FOR DISPLAY ON THEIR STOREFRONTS. WHILE THE DRINKING BINGE IMMORTALIZED BY THESE TRADEMARKS BECAME TEMPERED SOMEWHAT IN THE 1930s, THE FRENCH STILL TOASTED *LA JOIE DE VIVRE*.

Wines
ST. RAPHAËL
DESIGN: GIRAUDY • 1930

Beers & wines >
SOCIÉTÉ ANONYME DES GRANDES
BRASSERIES DE JARNY ET UCKANGE
JARNY • 1933

Wines
ANTONIN RODET
BOURGNEUF-VAL-D'OR • 1930

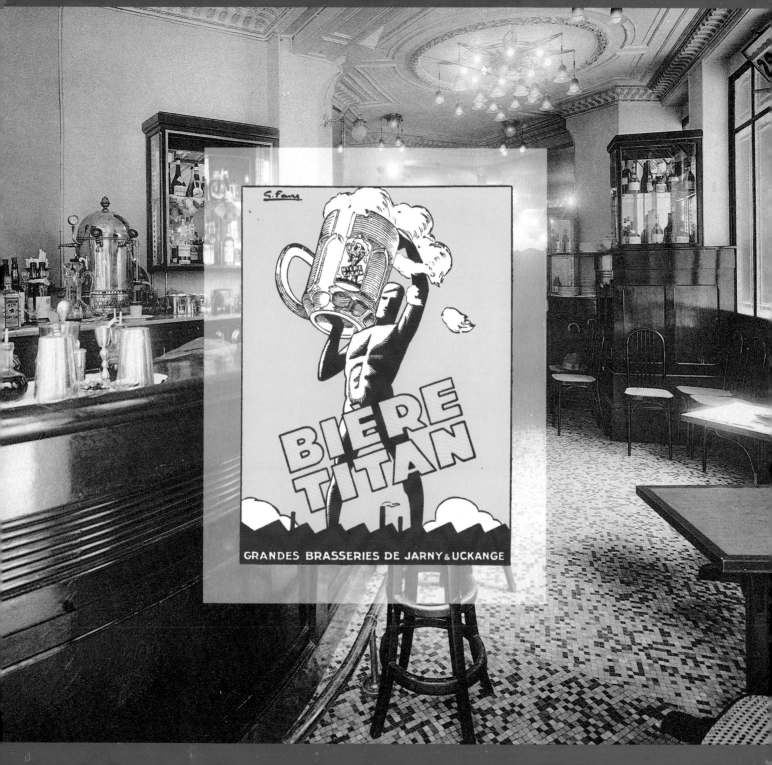

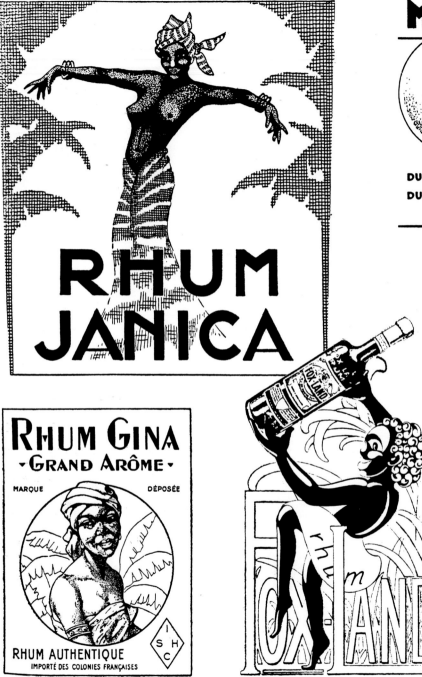

MIQUETTE

DU RHUM
DU CURAÇAO

RHUM JANICA

RHUM GINA
·GRAND ARÔME·

MARQUE DÉPOSÉE

RHUM AUTHENTIQUE
IMPORTÉ DES COLONIES FRANÇAISES

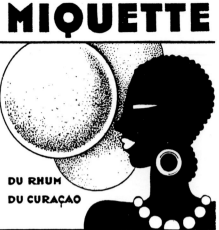

∧ *Rum*
ALFRED & VICTOR TOUTAIN
LE HAVRE • 1933

Liqueurs
SOCIÉTÉ GRIL FRÈRES
ALGER • 1932

< *Rum*
SOCIÉTÉ HAVRAISE D'IMPORTATION COLONIALE
LE HAVRE • 1931

Rum & spirits
JEAN & MARIE CASSIN
NICE • 1931

RHUM
MARINA
PRODUCT OF MARTINIQUE
FRENCH WEST INDIES

UN CANAR

RHUM
MONA

RHUM
SUPA

VIEUX MARTINIQUE

∧ *Rum*
RHUMERIE MARTINIQUAISE
PARIS • 1934

Rum
AIMÉ ROGER
MONTPELLIER • 1930

Rum >
A. TEISSÈDRE ET CIE
BORDEAUX • 1934

∧ Beer
BRASSERIE METEOR
HOCHFELDEN • 1933

Beer
GEORGES WASIER DE PLASSE
CYSOING • 1933

< Beer
GUSTAVE DELIÈRE-BECQUET
BÉTHUNE • 1933

Beer
GEORGES LECQ FILS
LA LONGUEVILLE • 1931

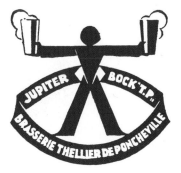

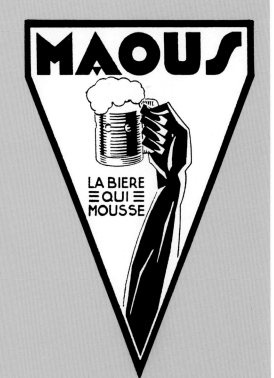

^ *Beers & mineral waters*
BRASSERIE DE SAINT-DENIS
PARIS • 1930

Beers >
BRASSERIE M. THELLIER DE PONCHEVILLE
SALLAUMINES • 1931

Beer
BRASSERIE MONTPLAISIR
TOULOUSE • 1933

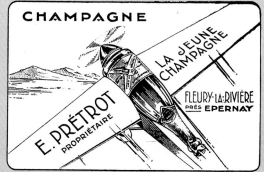

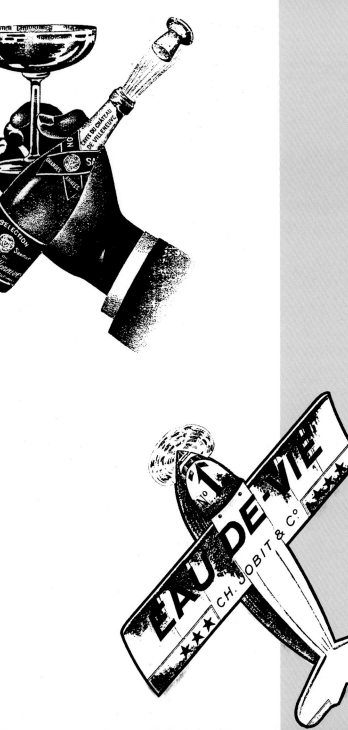

< Sparkling wines
CAVES DU CHÂTEAU DE VILLENEUVE
SOUZAY • 1933

Brandy
MAISON CH. JOBIT ET CIE
COGNAC • 1933

∧ Champagne
EDOUARD PRÉTROT
FLEURY-LA-RIVIÈRE • 1932

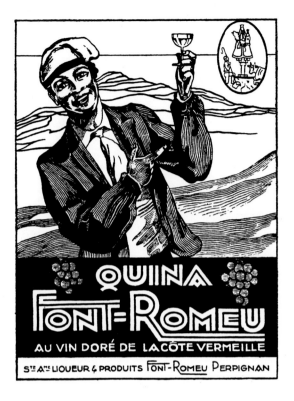

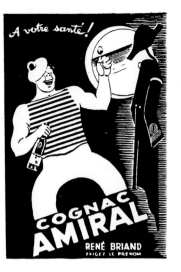

Aperitif
SOCIÉTÉ ANONYME: LIQUEUR ET PRODUITS
FONT-ROMEU
PERPIGNAN • 1931

Cognac
RENÉ BRIAND
COGNAC • 1933

Wine >
AUGUSTE ROUMILHAC
BORDEAUX • 1931

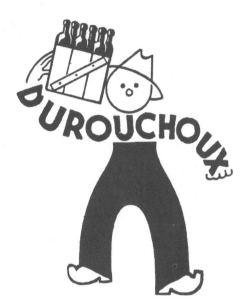

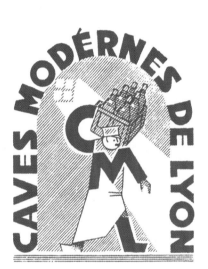

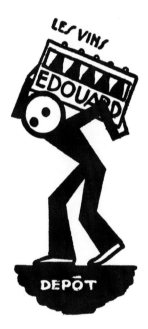

Wines & spirits
DUROUCHOUX FRÈRES
CHARENTON • 1932

Wines
SOCIÉTÉ ANONYME: LES CAVES
MODÉRNES DE LYON
LYON • 1933

Wines
LOUIS RÉMY
POITIERS • 1934

*Three-dimensional plaster display
for wine, beer and spirits*
Société Anonyme de la Grandé Distillerie
E. Cusenier Fils Aîné et Cie
Paris • 1932

GRIMA

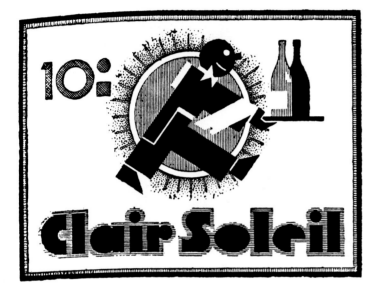

MON TONNEAU

∧ Wines
SOCIÉTÉ ANONYME DES DOCKS RÉMOIR
BÉTHENY-REIMS • 1930

Wines & spirits >
ROGER GRIMA
PARIS • 1932

Wines
ALEXANDRE DELAMARE
ELBEUF • 1931

Wines & spirits
SOCIÉTÉ À RESPONSABILITÉ LIMITÉE
C.A.M.E.C.
TOULOUSE • 1931

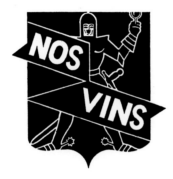

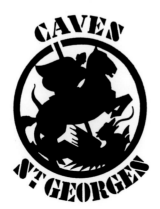

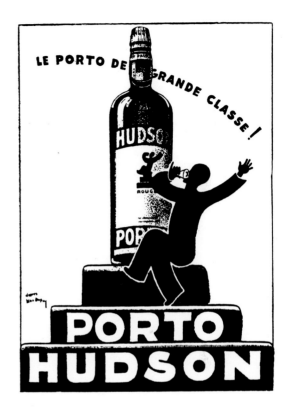

∧ *Wines & spirits*
BRUNET PÈRE ET FILS
LE HAVRE • 1933
DESIGN: LÉON DUPIN

< *Wines*
SOCIÉTÉ ROGER LAFON ET CIE
CHARENTON • 1930

Wines
GERME ET CIE
CAMBRAI • 1933

Wines & spirits
CAMILLE MURATET
BOULOGNE-SUR-SEINE • 1931

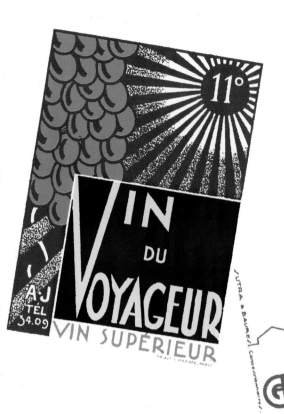

< Wines & spirits
ALBERT JOSSE
LA HAVRE • 1931

Aperitifs
ADOLPHE VINAY
MONTOLIVET-MARSEILLE • 1931

Wines
JEAN SUTRA & ARMAND BAURES
BÉZIERS • 1932

Wines & aperitifs
ANDRÉ CHARLOT
PARIS • 1934

Quinquina aperitif >
UNION VINICOLE DE L'HÉRAULT
LUNEL • 1934

Wines
YVES & MARIE PAUL
SAINT-POL-DE-LÉON • 1934

Wines
SOCIÉTÉ ANONYME DES DOCKS DE L'AUBE,
ETABLISSEMENTS ECONOMIQUES TROYENS
TROYES • 1932

Wines
FRANÇOIS & GABRIEL LABAUME
FONTENAY-AUX-ROSES • 1931

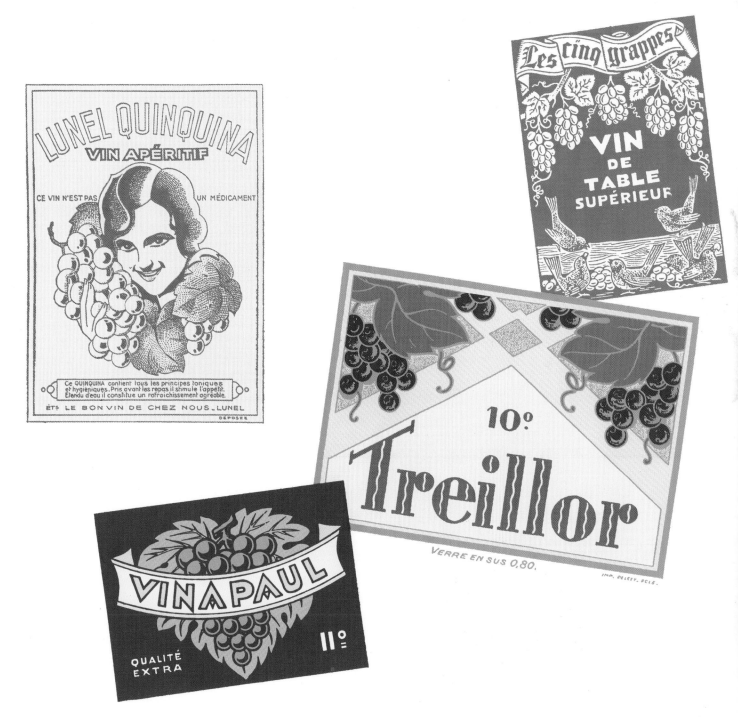

∧ Wines

LES VINS NATURELS DE FROUTIGNAN
FROUTIGNAN • 1933

Wines

VICTOR ANTHÉRIEU
FROUTIGNAN • 1933

∧ Wines

LES VINS NATURELS DE FROUTIGNAN
FROUTIGNAN • 1933

Sparkling wines

G. MOREAU ET CIE
NANTES • 1931

∧ Wines

LÉON JARLAUD
PARIS • 1930

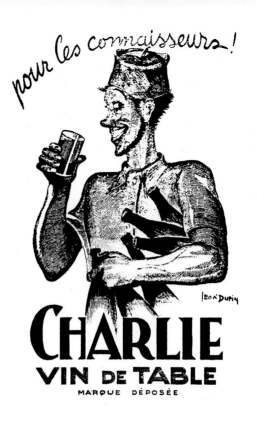

pour les connaisseurs !

CHARLIE
VIN DE TABLE
MARQUE DÉPOSÉE

UN PAULO
L'APÉRITIF
SUPÉRIEUR
A TOUS PRODUITS ANISÉS

∧ *Aperitif*
ALAIN THÉOPHILE
LE HAVRE • 1931

Wines & spirits >
PREMIER SYNDICAT DES EPICIERS
DÉTAILLANTS DE COLMAR
COLMAR • 1933
DESIGN: LÉON DUPIN

Wine
PAUL MÉNÉTREY ET CIE
SAINTE-FOY-LA-GRANDE • 1932

Wines
JACQUES AND MAURICE BÉDHET
PARIS-BERCY • 1931

GRAINDAROME

Roasted coffees
JEAN MOUSTROU
L'ISLE-SUR-SORGUE • 1931

Coffees WERE IMPORTED INTO FRANCE BY COMPANIES WHOSE TRADEMARKS ELOQUENTLY ALLUDE TO THE SPIRIT OF THE TIMES. THESE SKILLFULLY RENDERED DESIGNS ENCOMPASS A VARIETY OF IMAGERY, FROM BLACKS AND ARABS TO AIRPLANES AND OCEAN LINERS, AND ARE A VERITABLE SMORGASBORD OF IDEAS THAT WERE IN THE AIR THROUGHOUT THE ART DECO ERA. SOME OF THESE DISTINCTIVE TRADEMARKS TAKE A MORE DECORATIVE APPROACH TO ILLUSTRATION AND TYPOGRAPHY, WHILE OTHERS RELY ON GEOMETRIC COMPOSITIONS AND LETTER FORMS. THE SYMBOL FOR CAFÉ MARCEL IS A STRIKING EXAMPLE OF THE ROLE RUSSIAN CONSTRUCTIVISM PLAYED IN INFLUENCING ART DECO DESIGNERS DURING THE 1930s. SINCE COFFEE IMPORTATION AND COFFEEHOUSES FLOURISHED BETWEEN THE WARS, PERHAPS THE COMPETITIVE NATURE OF THE BUSINESS ENSURED A CONSISTENTLY HIGH QUALITY OF DESIGN. THE ARTISTRY IN THESE TRADEMARKS IS REMARKABLE.

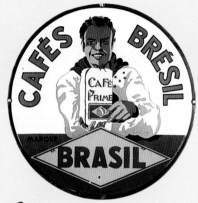

Coffees
CAFÉS BRÉSIL
JURA • 1920
DESIGN: EMAIL RENAUD

Coffee >
MAURICE RICCARDI
MONTAUBAN • 1933

Page 65

Coffees
HENRI & JULIEN LIMOUSIN
CHERBOURG • 1932

CAFÉS RICC
MONTAUBAN

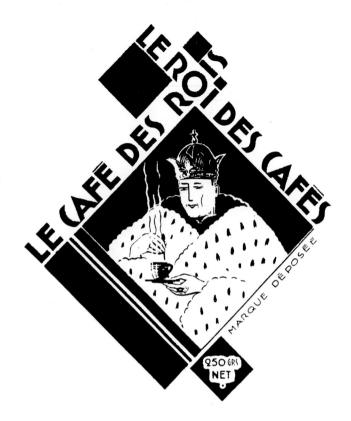

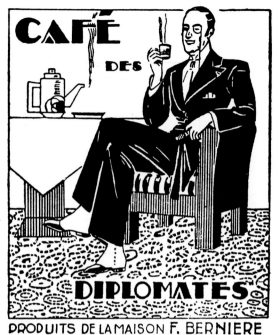

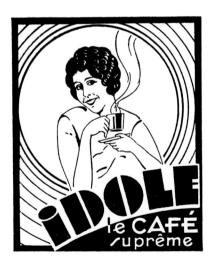

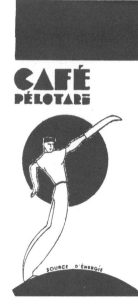

∧ Roasted coffee
PAUL LAMORTE
GRENOBLE • 1931

Coffees
FRANÇOIS BERNIÈRE
LÉZIGNAN-CORBIÈRES • 1933

< Coffees & teas
ABEL PRAT
FORCALQUIER • 1931

Coffees
SOCIÉTÉ PYRÉNÉENNE D'ALIMENTATION
SAINT-JEAN-DE-LUZ • 1935

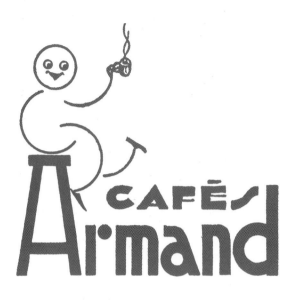

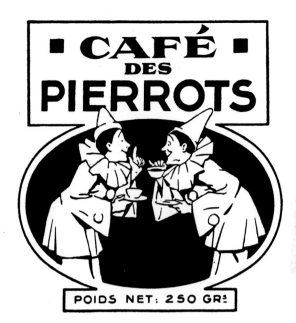

POIDS NET: 250 GRˢ

∧ Roasted coffees
SOCIÉTÉ À RESPONSABILITÉ
LIMITÉE ODIER ET FILS
MARSEILLE • 1932

Coffees
ANDRÉ CARTON
NOGENT-LE-ROTROU • 1930

Coffees >
PABLO LATORRE
MONTPELLIER • 1933

Roasted coffees & teas
SOCIÉTÉ ANONYME TORRÉFACTION
DES CHARTREUX
MARSEILLE • 1930

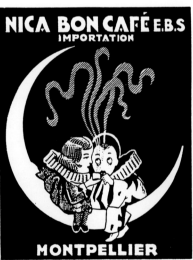

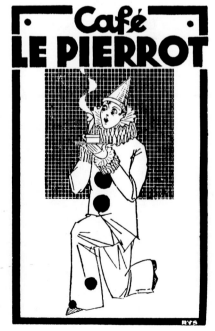

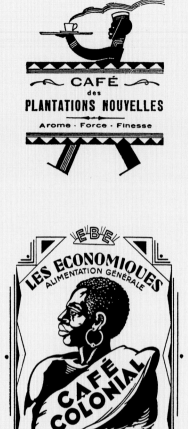

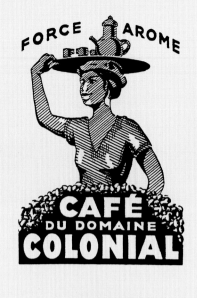

LES CAFÉS DE L'HACIENDA

CAFÉ des PLANTATIONS NOUVELLES
Arome · Force · Finesse

FORCE AROME
CAFÉ DU DOMAINE COLONIAL

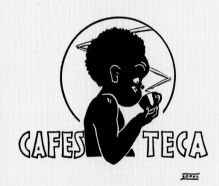

CAFES TECA

EBE
LES ECONOMIQUES
ALIMENTATION GÉNÉRALE
CAFÉ COLONIAL
TORRÉFACTION QUOTIDIENNE
BESANÇON

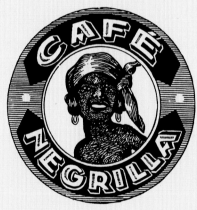

CAFÉ NEGRILLA

Coffees
MARIE CAPRON
ROUEN • 1930

Coffees & teas
CAFES TECA
STRASBOURG • 1932

Coffees
TORRÉFACTION DE LA CAPELETTE
MARSEILLE • 1933

Colonial coffee
ETABLISSEMENTS ÉCONOMIQUES BISONTINS
BESANÇON • 1932

Coffee, chocolate, & cocoa
JULIEN LEVEUGLE
ROUBAIX • 1933

Coffees
SOCIÉTÉ À RESPONSABILITÉ LIMITÉE
LANDON ET CIE
LIMOGES • 1933

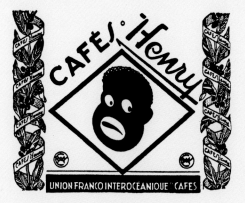

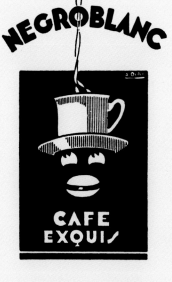

NEGROBLANC

CAFE EXQUIS

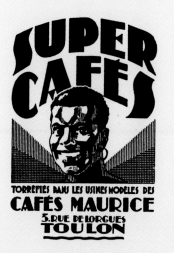

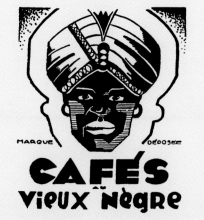

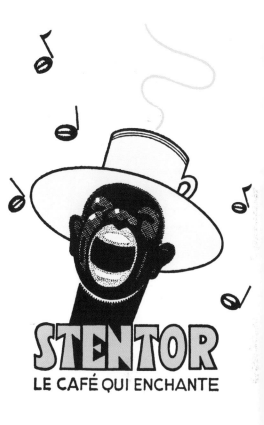

STENTOR
LE CAFÉ QUI ENCHANTE

Coffees & teas
Union Franco-Interocéanique des Cafés
Paris • 1933

Coffees
Société Lévy frères
Toulon • 1930

Coffee
Etablissements Pomor
Béziers • 1930

Coffees
Jean-Baptiste Haennig
Belfort • 1934

Roasted coffee
Société Centrale de Torréfaction
Rouen • 1932

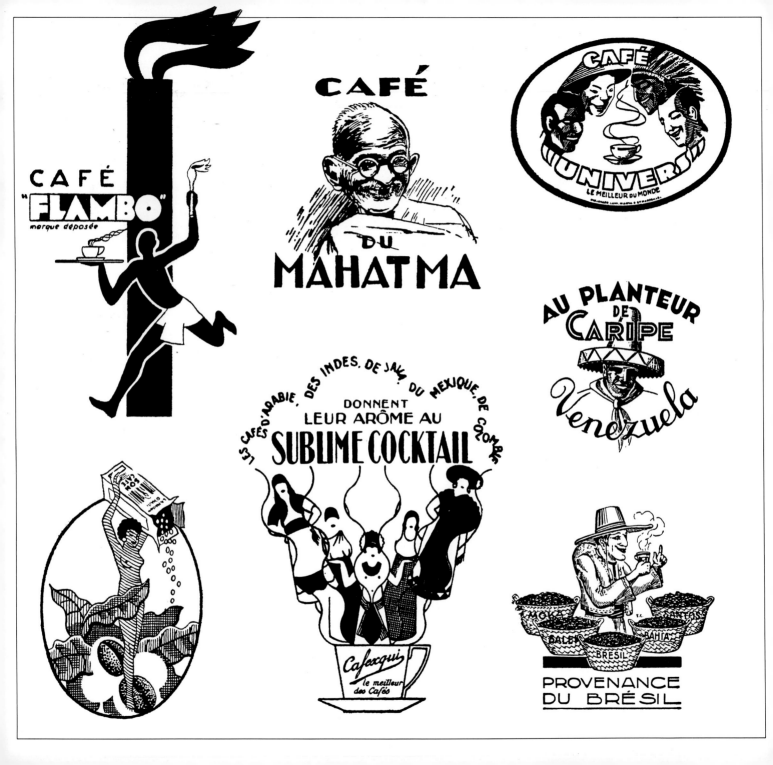

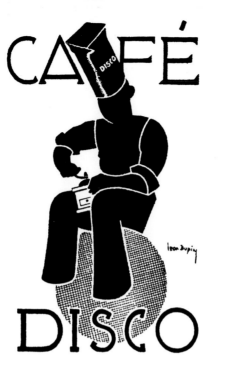

Page 70, clockwise from top left

Coffee
LUCIE LEVINSKY
ROUEN • 1931

Roasted coffee
ALPHONSE TOURRÈS
MARSEILLE • 1931

Coffees & teas
MATHIEU SILVANI
MARSEILLE • 1930

Venezualan coffees & teas
JOSEPH, OLIVIÉRI, & ANTOINE SIMONPIÉTRI
MARSEILLE • 1932

Brazilian coffees
GENEVIÈVE SERRANO
AVIGNON • 1934

Roasted coffees & chicorées
SOCIÉTÉ ETABLISSEMENTS BOURDILLON
PARIS • 1931

Roasted coffee
LA MAISON D'HAÏTI
ISSY-LES-MOULINEAUX • 1933

Coffees
J. BRUTSCHE ET CIE
LE HAVRE • 1932
DESIGN: LÉON DUPIN

Coffees
MARGUERITE LEMOINE
LYON • 1931

LES CAFES DU GRAND CROISSANT

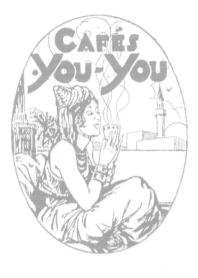

CAFÉS .You-You

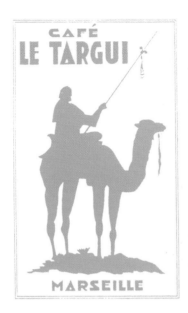

CAFÉ LE TARGUI

MARSEILLE

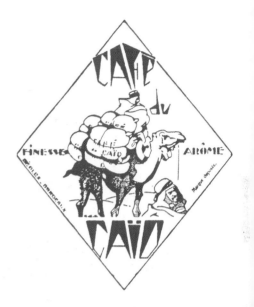

CAFÉ du CAÏD

FINESSE — ARÔME

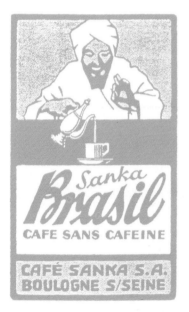

Sanka Brasil

CAFE SANS CAFEINE

CAFÉ SANKA S.A.
BOULOGNE S/SEINE

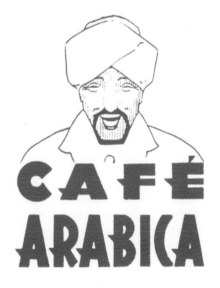

CAFÉ ARABICA

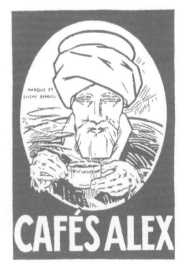

CAFÉS ALEX

73

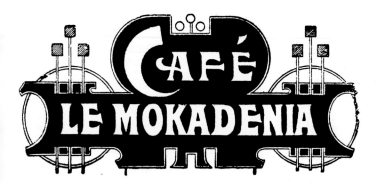

CAFÉ
LE MOKADENIA

les
Cafés
Gitana

s'imposent
par
leur finesse

POIDS NET:
250 Gr.

MARQUE DÉPOSÉE
MARQUE DÉPOSÉE

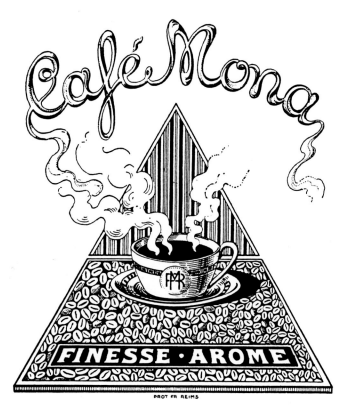

Café Mona

FINESSE · AROME

PROT FR REIMS

CHOCOLAT
KÉPÉPER

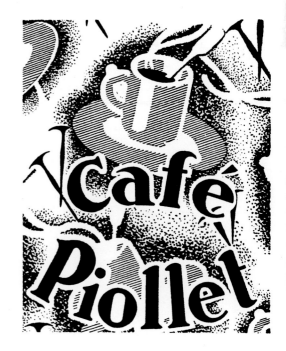

Coffees
ETABLISSEMENTS ED. SIMON ET CIE
BORDEAUX • 1932

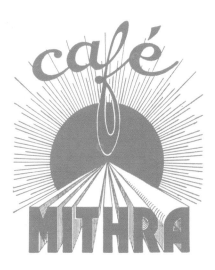

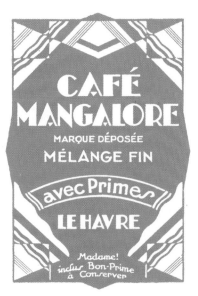

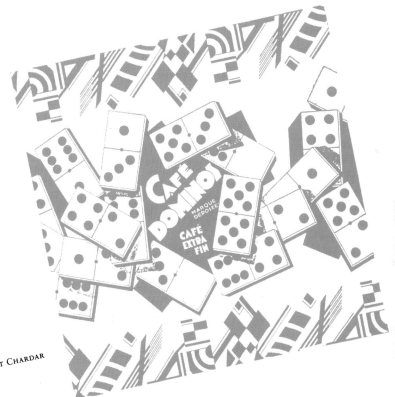

Coffees
SOCIÉTÉ DELAHAIS ET CHARDAR
EVREUX • 1930

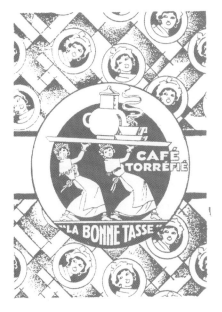

< *Coffees*
GEORGES COLLAS
STRASBOURG • 1931

Coffees
HENRI & GEORGES HANOT
HARGICOURT • 1932

Coffees
SOCIÉTÉ: BRÛLERIE MANGALORE
LE HAVRE • 1930

Roasted coffee
DUVAL-LEMONNIER
CARENTAN • 1931

Coffees & teas
RAYMOND CHÂTEL
LE HAVRE • 1931

Café TORRÉFIÉ A MEULAN

Roberta
MARQUE DÉPOSÉE

CAFÉ PONT-ROUGE

CAFÉ ARCOR

CAFÉ DE LA BASTILLE
A PRIMES

CAFÉ PANAM

Top row

< **Roasted coffee**
ROBERT & EUGÈNE FONTAINE
MEULAN • 1933

Coffee
SOCIÉTÉ ALAIN BALAT ET CIE
PERPIGNAN • 1933

Center

Coffees
SOCIÉTÉ ANONYME DE TORRÉFACTION
DES CAFÉS VENÉZUELA
PARIS • 1931

Bottom row

Coffees, teas & chocolates
PIERRE ASSELIN
PANTIN • 1932

Coffees >
AGENCE HAVAS
PARIS • 1931

Chicorée
WILLIOT FILS
NEUILLY-SUR-SEINE • 1930

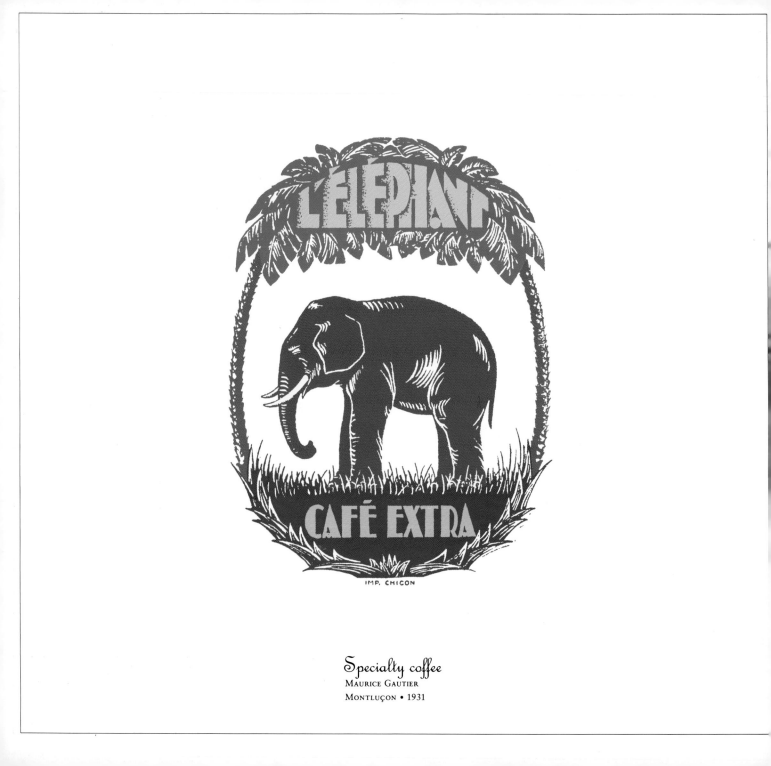

Specialty coffee
MAURICE GAUTIER
MONTLUÇON • 1931

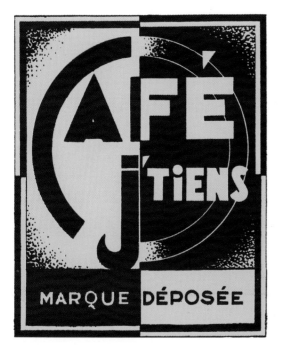

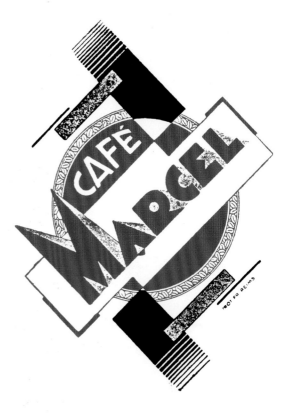

Coffee
Léon L'Heureux
Sainghin-en-Weppes • 1934

Coffees & teas
Société Michaud Frères et Fils
Moulins • 1934

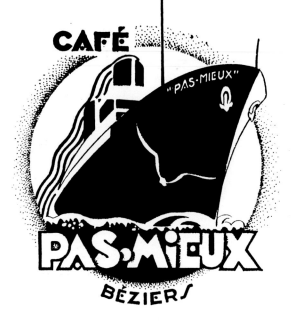

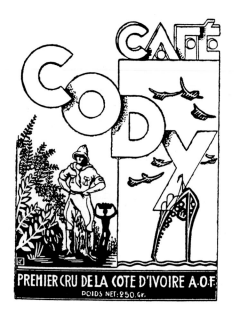

Coffee & cocoa
PRODUIT PRIMES "LA RENOMMÉE"
BÉZIERS • 1932

Coffee
SOCIÉTÉ BELIN VAISSEIX ET CIE
PARIS • 1934

Coffees >
RAYMOND LAJEUNESSE ET CIE
SAINT-DENIS • 1934

Roasted coffees
GERMAIN D'ALBERT
PERPIGNAN • 1931

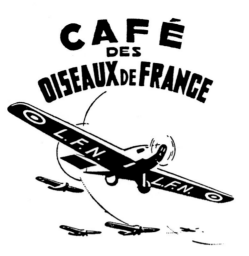

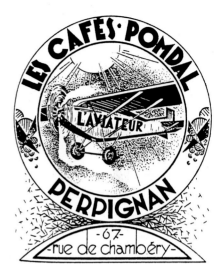

Coffees, teas & food >
SOCIÉTÉ ANONYME VOSGES
EPINAL • 1931

Coffees
L'INDÉPENDANTE
LILLE • 1933

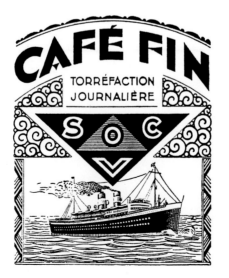

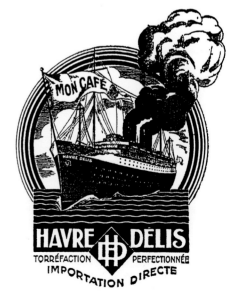

NECKTIES
SOCIÉTÉ SOLINSKI FRÈRES
PARIS • 1931

Haute couture AND THE APPRECIATION OF FINE

CLOTHING WERE SYNONYMOUS WITH THE FRENCH WAY OF LIFE DURING THE 1920S

AND 1930S. AFTER WORLD WAR I, PAUL POIRET CREATED STRIKING, IF EXCESSIVE,

FASHIONS IN THE ART DECO STYLE. HIS COSTUMES FOR THE ENTERTAINER JOSEPHINE

BAKER, DARLING OF THE PARIS INTELLIGENTSIA, WERE FLAMBOYANT MASTERPIECES.

FASHIONS CHANGED TOWARDS THE END OF THE 1920S, AS WOMEN LOOKED FOR

SIMPLER, LESS EXTRAVAGANT CLOTHES THAT REFLECTED A MORE RELAXED LIFE-

STYLE. THE COUTURIÈRE COCO CHANEL RESPONDED TO THESE NEW NEEDS WITH

FASHION GEARED TO A WIDE RANGE OF WOMEN. CHANEL DESIGNED CASUAL, UNFUSSY

CLOTHING MADE FROM JERSEY, COTTON, AND KNITTED MATERIALS, BASED ON THE

PHILOSOPHY THAT "EACH FRILL DISCARDED MAKES ONE LOOK YOUNGER."

EMULATING THIS ATTITUDE, THE TRADEMARKS OF CLOTHING MANUFACTURERS

BECAME SIMPLER IN FORM DURING THE 1930S, COMMUNICATING WITH AN ECONOMY

OF LINE BUT AN ABUNDANCE OF SPIRIT.

MODÈLES HAUTE COUTURE

DRESSES
MAISON NICOLL
PARIS • 1932

LINGERIE >
ETABLISSEMENTS RAGUET ET VIGNES
TROYES • 1932

CAPS
JOSEPH MONCOMBLE
DEUIL • 1934

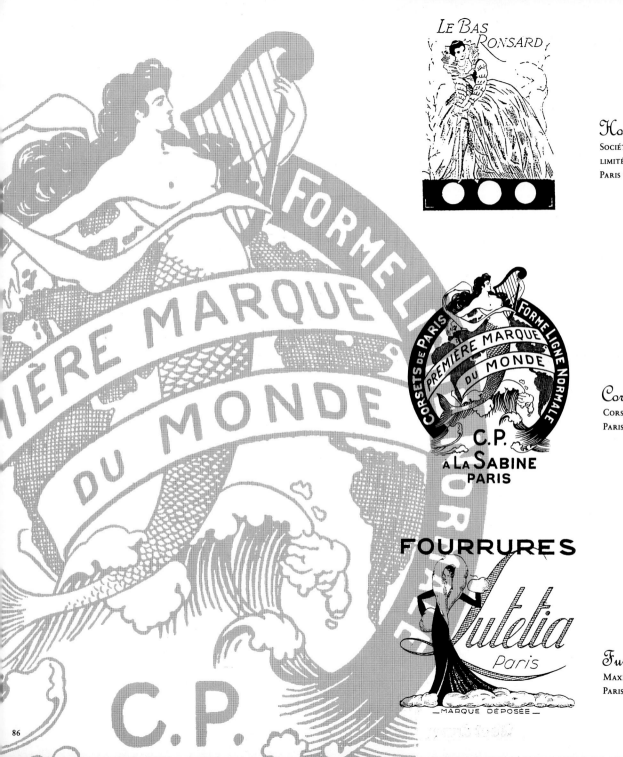

Hosiery
Société à responsabilité
limitée Ronsard
Paris • 1932

Corsets
Corsets Sirène
Paris • 1929

Furs
Maxime Svart
Paris • 1931

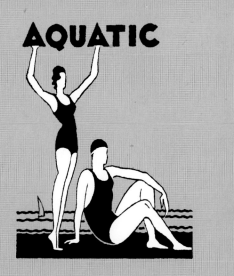

AQUATIC

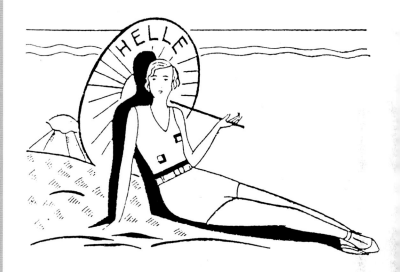

HELLE

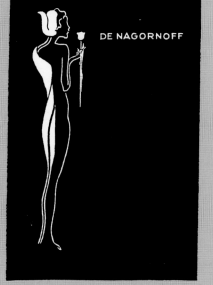

DE NAGORNOFF

Bathing suits
SOCIÉTÉ ANONYME LÉON HELLE ET CIE
PARIS • 1931

Hosiery
ETABLISSEMENTS LÉONCE MOMBOUNOUX
QUISSAC • 1934

Lingerie
WINKA DE NAGORNOFF
PARIS • 1934

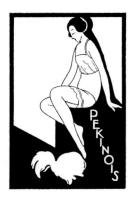

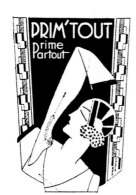

Hosiery
A. CAVROIS ET FILS
ROUBAIX • 1931

Hosiery
FILTIS
LILLE • 1934

Hosiery
LOUIS AUDONNEAU
REIMS • 1932

Hosiery
SOCIÉTÉ PERFECTA BONNETERIE
PARIS • 1929

Hosiery
MANUFACTURE DE BONNETERIE
FINE DE SEINE-ET-MARNE
PARIS • 1928

Hosiery
A. ROGER ET CO.
SAINT-ANDRES-LES-VERGERS • 1931

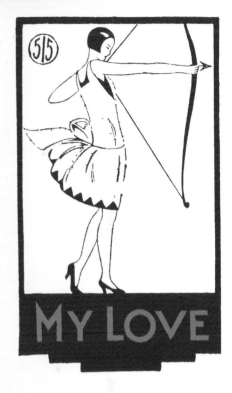

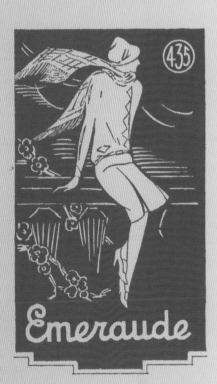

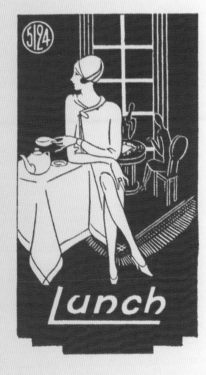

Hosiery
SOCIÉTÉ PERFECTA BONNETERIE
PARIS • 1929

Ribbons
ANTOINE PICHON
SAINT-ETIENNE • 1931

Caps
GOLLY-FLOSSE ET CIE
EPERNAY • 1933

Wool sweaters
CLAUDE FICHEN
BREST • 1932

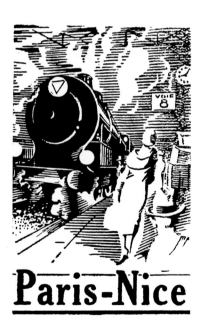

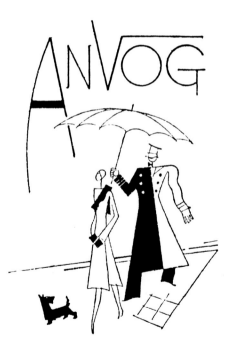

Hosiery
EDOUARD DELAQUIS
TROYES • 1933

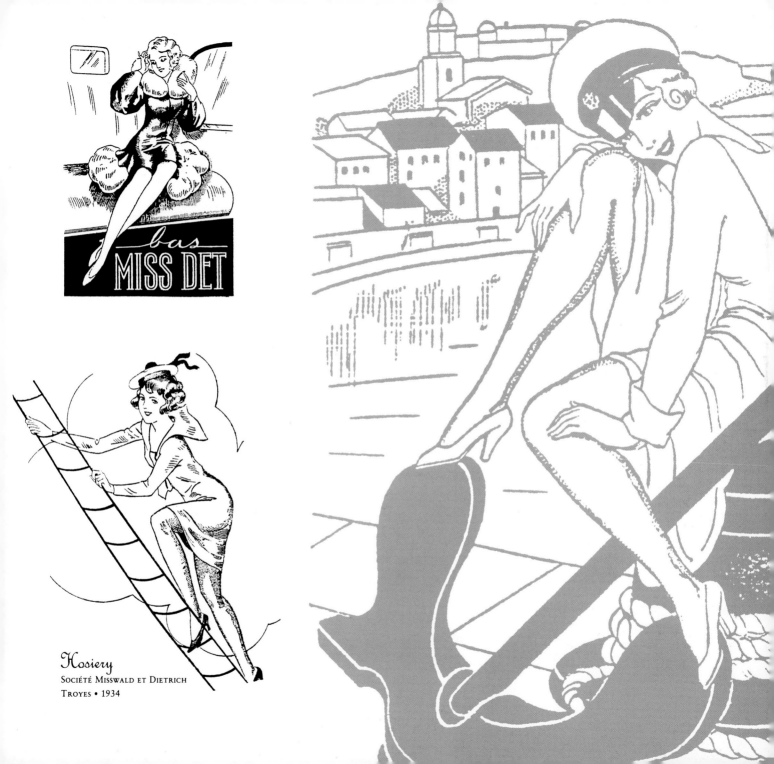

bas
MISS DET

Hosiery
SOCIÉTÉ MISSWALD ET DIETRICH
TROYES • 1934

Men's clothing
GRAND BON MARCHÉ
MONTPELLIER • 1933

Clothing
MARCEL BLOCH
NANTERRE • 1933

Raincoats
RAFAL & HERSZ FRENKEL
PARIS • 1932

La pluie ne l'atteint pas!

PLUITEX
IMPERMEABLE

Raincoats
OTTO HAYMANN
PARIS • 1935

EN **K** DO

MAISON FONDÉE EN 1851
PARAPLUIE-REVEL
LYON (FRANCE)

VERITAS VERITAS
VERITAS

The very best umbrella manufacturer
Established 1851

Marque déposée MADE IN FRANCE Trade Mark

Umbrellas
PARAPLUIE-REVEL
LYON • 1922
DESIGN: LEONETTO CAPPIELLO

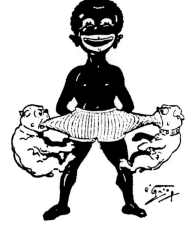

Brassières
HENRI SIMONET
ANGERS • 1933

Zippers
MARCEL, LOUIS, & MARIE POMEY
IVRY-SUR-SEINE • 1931

Suspenders
SOCIÉTÉ: MAURICE DUFOUR ET FILS
PARIS • 1930

Hosiery
BERTHE & AUGUSTINE BAUER
NANCY • 1932

Underwear
COMPAGNIE FRANÇAISE POUR LA
FABRICATION DE BAS ET SOUS-VÊTEMENTS
PARIS • 1931

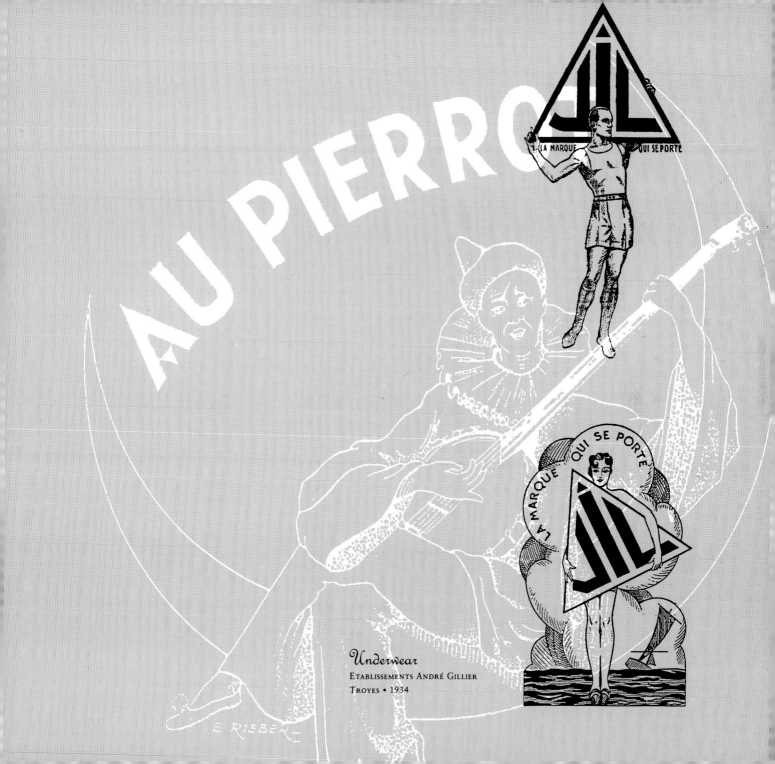

AU PIERRO

Underwear
ETABLISSEMENTS ANDRÉ GILLIER
TROYES • 1934

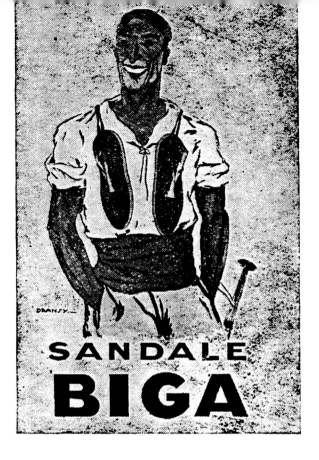

< Sandals & espadrilles
ETABLISSEMENTS LOUIS BEGUERIE
MAULÉON-SOULE • 1932
DESIGN: DRANSY

Bottom row

Clothing
LE VÊTEMENT OUVRIER
LE CREUSOT • 1930

Shoes
PROSPER GEYRÉ
BRUYES • 1931

Clothing
SOCIÉTÉ INDUSTRIELLE DU VÊTEMENT
ELBEUF • 1931

Lingerie >
SOCIÉTÉ ANONYME: MAISON JODELLE
PARIS • 1934

Gloves, corsets, & hosiery
SOCIÉTÉ ANONYME: GANT PERRIN
GRENOBLE • 1931

Galoshes
LOUIS CHAMARD
LE PUY • 1929

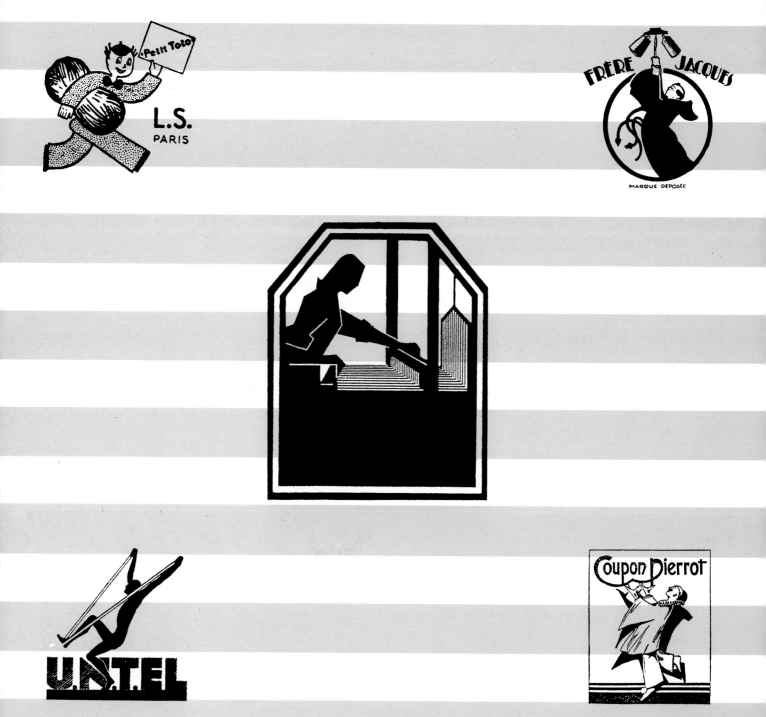

< *Top row*

Wool yarn
Levert et Soullier
Paris • 1933

Thread
Société A. Dumond, J. Chanson et Cie
La Talaudière • 1933

Center

Cotton & silk fabrics
Société Anonyme Comptoir de
l'Industrie Cotonnière
Paris • 1930

Bottom row

Laces & braid
Claude Boissonnat
Saint-Julien-en-Jarez • 1931

Thread, fabrics, & elastics
Union Nationale des Fabricants
de Tissus Elastiques U.N.T.E.L.
Paris • 1932

Wool yarn >
Paul Bécus
Elbeuf • 1934

Cotton thread
Société des Fils à Coudre
de Provence
Marseille • 1932

Fabrics
Société Nouvelle de la
Blanchisserie et Teinturerie
Paris • 1934

POUR VOS LAINAGES
DEMANDEZ
FILANGOR
FIL ANGORA
INCOMPARABLE
CHALEUR DOUCE L'HIVER - BIEN-ÊTRE L'ÉTÉ

A L'AS DES AS
GUYNEMER
I.A.J.

ASTRAL
SN BTT
FINISH

Ropes
SOCIÉTÉ ANONYME LA JEANNE D'ARC
EPINAL • 1930

Products OF ALL KINDS WERE MANUFACTURED DURING THE BOOM YEARS OF THE 1920S. THE AFFLUENCE OF THIS DECADE USHERED INTO FRANCE A RAMPANT CONSUMERISM, THE LIKES OF WHICH HAD NOT BEEN SEEN SINCE *LA BELLE EPOQUE* OF THE LATE 19TH CENTURY. SHOPPING WAS A POPULAR ACTIVITY, AND LARGE STORES SUCH AS LA SAMARITAINE AND GALERIES LAFAYETTE BROUGHT A WIDE ASSORTMENT OF GOODS TO AN EAGER PUBLIC. FROM AUTOMOBILES AND THEIR ACCESSORIES TO FURNISHINGS FOR THE HOME, OPULENCE AND COMFORT WERE THE IDEALS TO WHICH MOST STRIVED. TRADEMARKS REFLECT THIS UPBEAT MOOD: MUSCULAR MEN, LIGHTNING BOLTS, AND THE DRAMATIC PRESENTATION OF CONSUMER PRODUCTS WERE COMMON THEMES. DURING THE 1930S MATERIALISM WANED AS FRANCE SLIPPED INTO ECONOMIC DEPRESSION, THEN FINALLY WAR. YET THE EXUBERANCE OF THESE SYMBOLS REMAINS A TESTAMENT TO THIS GOLDEN AGE OF FRENCH CAPITALISM AND GRAPHIC DESIGN.

Electric lights
MARC & ANTOINE LINAS
NICE • 1933

Chemical fertilizers >
SOCIÉTÉ ANONYME POTASSE
ET ENGRAIS CHIMIQUES
PARIS • 1930

Automobile wax
ROBERT FRÉMAUX
BOURG-LA-REINE • 1932

Automobile wax & paints
ARTHUR VAN DER BRUGGEN
PARIS • 1930

Automobiles
SOCIÉTÉ ANONYME ANDRÉ CITROËN
PARIS • 1933

Trucks
SOCIÉTÉ ANONYME CAMIONS BERNARD
ARCUEIL • 1931

Automobile coachwork
SOCIÉTÉ ANONYME: CARROSSERIE MULHOUSE
MULHOUSE • 1935

FELUX AUTO

Automobile wax
FÉLIX FOURNIER
MARSEILLE • 1930

POLISH

BELFINOR

^ Automobile wax
FERNAND FIMBEL
STRASBOURG • 1934

Automobile wax >
MARCEL & EDOUARD LEROY
PARIS • 1934

Radiator coolant
RUDOLF MENASSÉ-MORRIS
MONTESSON • 1934

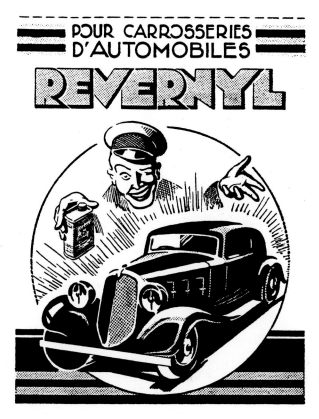

POUR CARROSSERIES D'AUTOMOBILES

REVERNYL

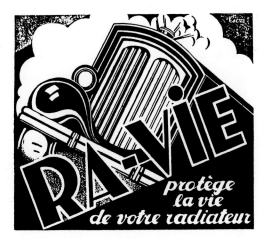

RAVIE
protège
la vie
de votre radiateur

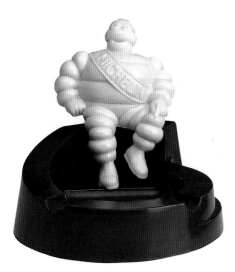

Michelin Man ashtray
MICHELIN TIRE & RUBBER COMPANY
CLERMONT-FERRAND • c. 1930

∨ ## Automobile tires
ERIC & SHELDON ROWLANDSON
TROUVILLE • 1937

Automobile tires
SOCIÉTÉ FRANÇAISE B.F. GOODRICH
COLOMBES • 1931

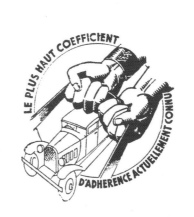

Automobile brakes
EDMOND & ANTOINE MALIGNON
PARIS • 1933

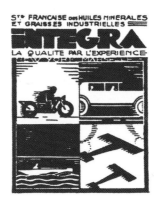

Lubricants
ARLETTE ROUX
SALON • 1931

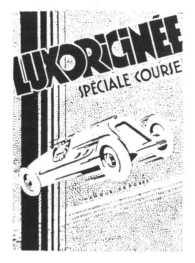

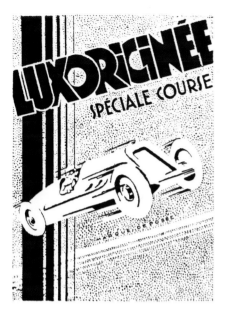

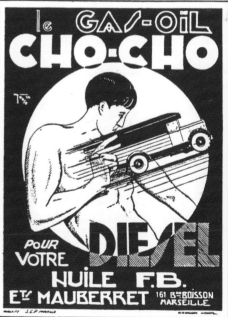

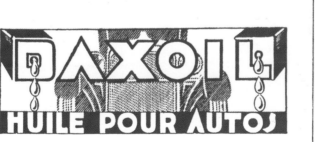

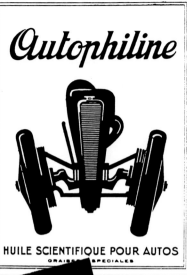

HUILE SCIENTIFIQUE POUR AUTOS

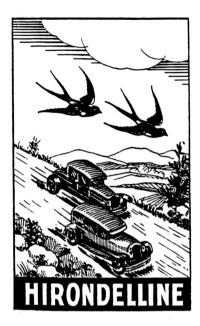

HIRONDELLINE

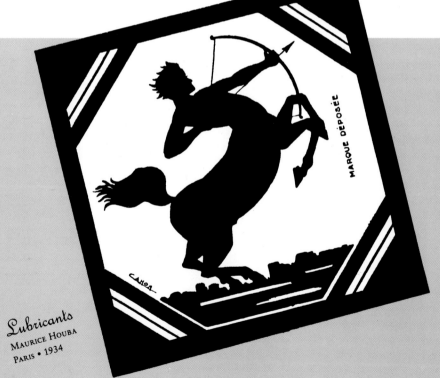

Lubricants
MAURICE HOUBA
PARIS • 1934

^ Lubricants
JOSEPH GEORGERENS
BÉZIERS • 1930

Automobile oil & gas
PIERRE PEYTAVIN DE GARAM
MARSEILLE • 1930

Lubricants
ACHILLE LEQUIN
TOURCOING • 1933

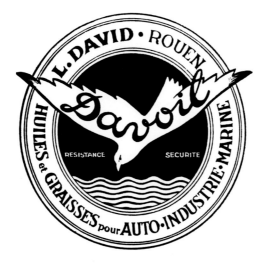

Lubricants
Léon, Maximilien, & Jean David
Rouen • 1933

Automobile oil
Francis Ranque
Lyon • 1932

Lubricants
Garrigue et Challou
Bordeaux • 1932

Industrial oils & gas >
Société pour l'Utilisation
Rationnelle des Gaz
Paris • 1937

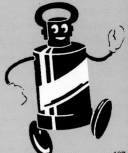

^ *Razors*
Société Soutilla
Strasbourg • 1932

Boats >
Plein Air Sport
Paris • 1934

Circuit breakers
Société Française Gardy
Argenteuil • 1932

Industrial paints
Société Anonyme des Etablissements
Pierre P. Zecchini
Paris • 1931

RULLIÈRE FRÈRES, AVIGNON.

∧ Brooms
SOCIÉTÉ PAGET FRERES
COURTHEZON • 1930

< Oil & gas
PIERRE HERVÉ
LIBOURNE • 1933

Oil & lubricants
JACQUES COHEN
ORAN • 1932

Gas pumps
COMPAGNIE DES POMPES
ET DISTRIBUTEURS
SURESNES • 1933

Refrigeration equipment
SOCIÉTÉ ANONYME DES MACHINES
À TRICOTER EDOUARD DUBIED ET CIE
PARIS • 1933

Furniture
JACQUES PFALZGRAF
BOUXVILLER • 1932

Metal products
HARRY SCHÖNBERG
PARIS • 1931

Waterproof fabrics
SOCIÉTÉ ANONYME SAINT FRÈRES
PARIS • 1932

Insecticide
GABRIELLE GRIFFIÉ
CAVANAC • 1933

Trunks & suitcases
VUITTON ET VUITTON
ASNIÈRES • 1931

Insecticide
LOUIS LACASA
ORAN • 1931

Rat poison
HENRI & ANTOINE COLLET
PARIS • 1931

Paper

Société Emile Avot fils et Cie
Lumbres • 1931

Straw mats

Curt Buhler
Haïphong • 1930

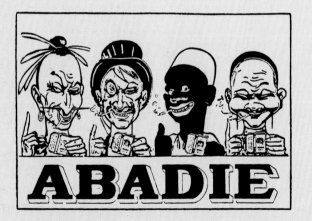

Cigarette papers

Société Anonyme des Papiers Abadie
Paris • 1937

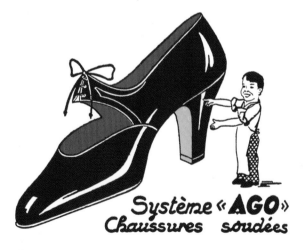

Shoe polish

Etablissements Roth Frères
Palatinat • 1933

Toy guns
GEORGES OLIVIER
PARIS • 1932

Toys
EDOUARD BIAIS & MARIUS ZANOLLI
MENTON • 1933

POUR CEUX QUI POUSSENT

Toys
RAYMOND DESCHAMP
VIERZON • 1933

COPYSTAT

souplex
101, rue de charonne 101
PARIS 11ᵉ
MARQUE DEPOSE

LE BOUIF MODERNE

L'ECOLE FRANÇAISE DU SKI

Floréal

Wrapping papers
GEORGES CHARRIAUD
ROUMAZIÈRES-LOUBERT • 1931

Typewriter ribbons
SOCIÉTÉ AMAVET, LAMOTHE ET TERRAS
MARSEILLE • 1931

Papers
SOCIÉTÉ EMILE AVOT FILS ET CIE
LUMBRES • 1931

Papers
SOCIÉTÉ MARTIN FRÈRES
PARIS • 1930

Wrapping papers
SOCIÉTÉ EMILE AVOT FILS ET CO
LUMBRES • 1930

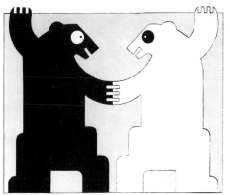

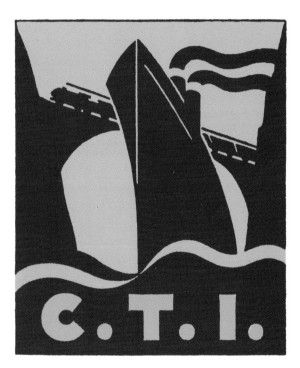

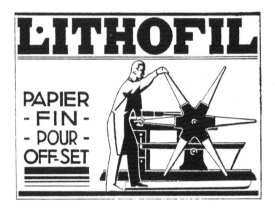

< Rubber stamps
ETABLISSEMENTS TIFLEX
PONCIN • 1930

Stationery & printed matter
SOCIÉTÉ ANONYME CENTRALE DE TRANSPORTS
INDUSTRIELS MARITIMES ET TERRESTRES
PARIS • 1930

^ Printing papers
EMILE AVOT FILS ET CO
LUMBRES • 1932

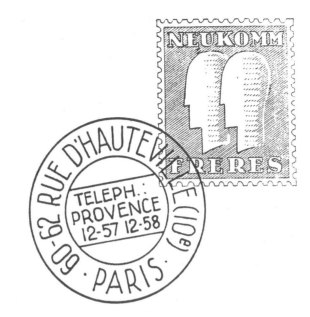

D'UN TRAIT JE TOUCHE

∧ *Advertising*
ASSURANCES L'INDUSTRIE
STRASBOURG • 1933

Advertising
FRÉDÉRIC & EMILE NEUKOMM FRÈRES
PARIS • 1931

Printed matter >
FRANCIS ELVINGER
PARIS • 1932

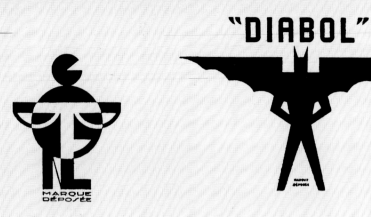

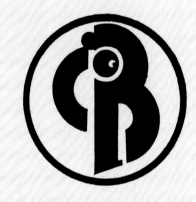

Cellulose
LOUIS MULLER ET FILS
PARIS • 1933

Building stones & tiles
HERMAN ZRYD
TOULOUSE • 1931

Objects d'art
GASTON NOBLET
PARIS • 1929

Charcoal
ABEL GOUNIN
BORDEAUX • 1931

Industrial chemicals
PIERRE & LÉON BLANCHOUD
PARIS • 1931

Combustibles
MAURICE DEMOLEIN
TOULOUSE • 1933

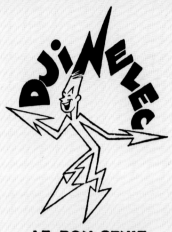

LE BON GENIE
DE L'ELECTRICITE

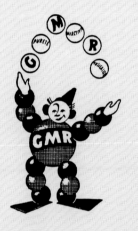

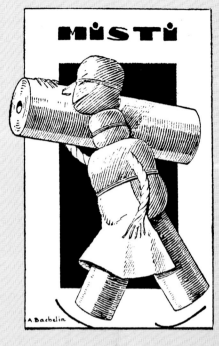

Electric equipment
NORD-LUMIÈRE
PARIS • 1929

Tinsmith
SOCIÉTÉ GESTION DE
L'ELECTRO-CALORIQUE
VILLEURBANNE • 1933

Heating & lighting
SOCIÉTÉ GAZ ET CHALEUR
NEUILLY-SUR-SEINE • 1932

Radio apparatus
ETABLISSEMENTS G.M.R.
MONTROUGE • 1937

Paper & cartons
HENRI PARQUET
PARIS • 1931

∧ *Beds*
SOCIÉTÉ MONDAIN ET CIE
ANGERS • 1934

Filing cabinets
FLAMBO
PARIS • 1934

Interior decoration >
MERCIER FRÈRES
PARIS • C. 1934
DESIGN: A. GIRARD

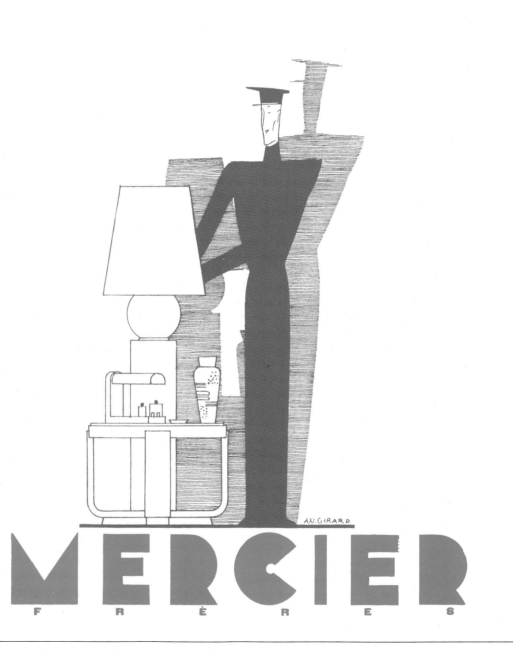

^ Steel furniture
SOCIÉTÉ ANONYME L'ORGANISATION
ECONOMIQUE MODERNE
PARIS • 1931

Scales >
SOCIÉTÉ D'EXPLOITATION
DE BREVETS ET INVENTIONS
PARIS • 1934

Brushes & sweepers
ETIENNE MOTTE ET CIE
ROUBAIX • 1932

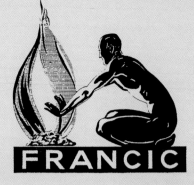

∧ *Paper tags*
SOCIÉTÉ ANONYME MANUFACTURE
DE PAPIERS HUBER FILS
STRASBOURG-SCHILTIGHEIM • 1933

∨ *Paper & cartons*
LABORATORIES PHARMACEUTIQUES EFFICIA
PARIS • 1934

∧ *Ladders*
ETABLISSEMENTS AUMAÎTRE ET MATHE
PARIS • 1932

∨ *Cabinet work*
SOCIÉTÉ FAVRE ET ROZIER
LANGRES • 1933

∧ *Coal*
SOCIÉTÉ FRANÇAISE DE COMMISSION
ET D'IMPORTATION DE TOUS COMBUSTIBLES
MARSEILLE • 1934

∨ *Metals*
BEZAULT FRÈRES
PARIS • 1931

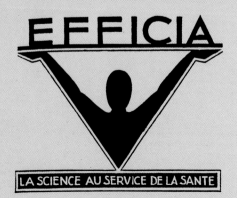

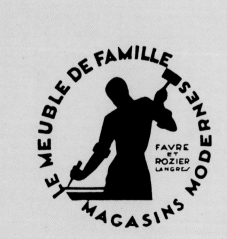

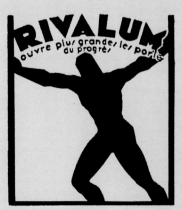

LE PARGAZ

TERRASSE LE MALFAITEUR

∧ *Gas blowers*
FRANÇOIS CUILLERY
PARIS • 1932

∨ *Roofing materials*
SOCIÉTÉ DESCHAMPS ET CO
PARIS • 1932

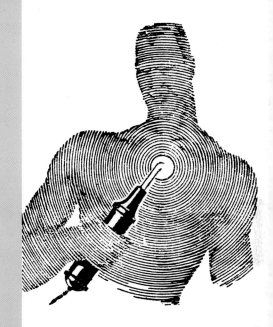

SEURALITE

∧ *Electric massage devices*
JACQUES LÉVY
PARIS • 1932

Electric advertising
ELECTRO-VOX
PARIS • 1933

Office machines
HENRI BRUN
NANCY • 1932

Bicycles
ETABLISSEMENTS VERNEY-CARRON
SAINT-ETIENNE • 1934

Kitchen stoves
SOCIÉTÉ AU BON FOYER
STRASBOURG • 1932

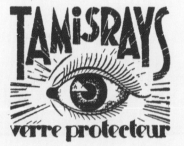

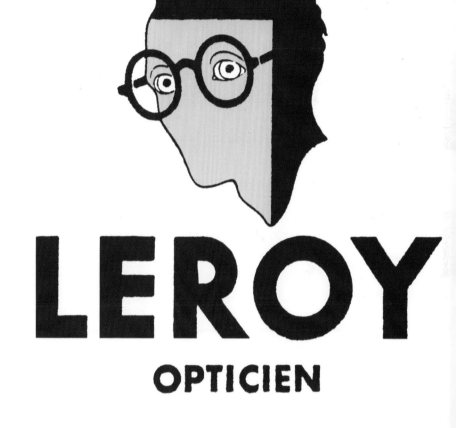

LEROY

OPTICIEN

^ *Cash drawers*
JEAN PACCAUD
AMIONS • 1934

Optical instruments
FRÉDÉRIC FLIZET
PARIS • 1934

Optical instruments
LEROY OPTICIEN
PARIS • 1934
DESIGN: A.M. CASSANDRE

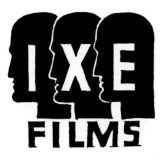

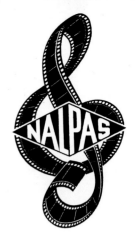

Motion pictures
MAURICE CAMUGLI
PARIS • 1933

Phonograph records
MICHAEL MUAULL
PARIS • 1930

Motion picture equipment
NALPAS
PARIS • 1931

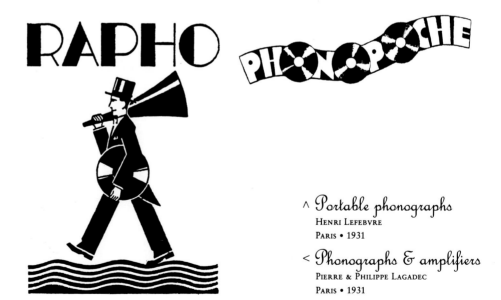

∧ Portable phonographs
HENRI LEFEBVRE
PARIS • 1931

< Phonographs & amplifiers
PIERRE & PHILIPPE LAGADEC
PARIS • 1931

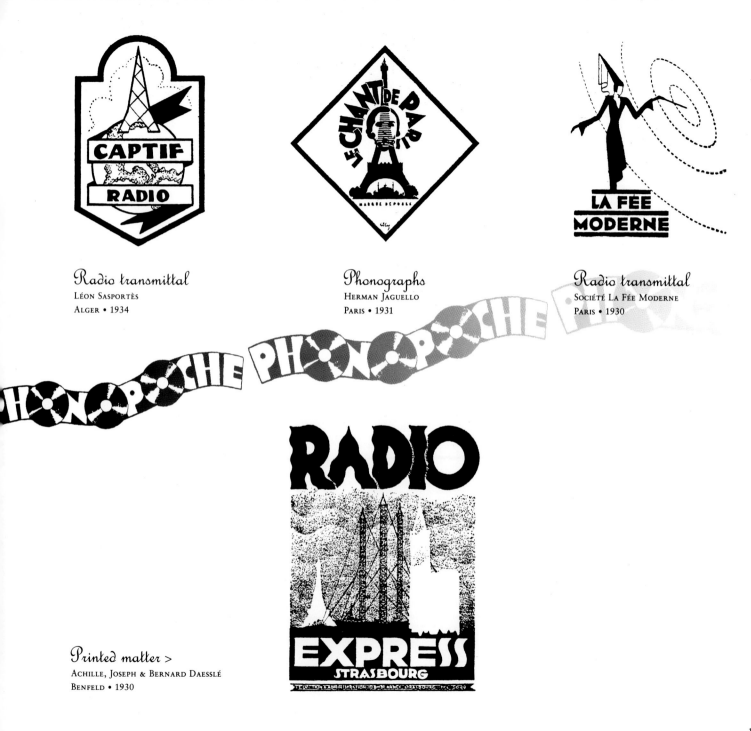

Radio transmittal
Léon Sasportès
Alger • 1934

Phonographs
Herman Jaguello
Paris • 1931

Radio transmittal
Société La Fée Moderne
Paris • 1930

Printed matter >
Achille, Joseph & Bernard Daesslé
Benfeld • 1930

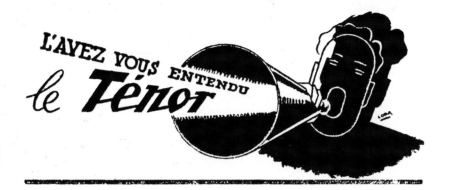

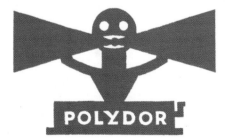

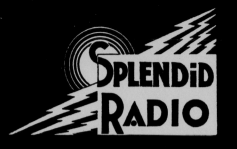

Splendid Radio

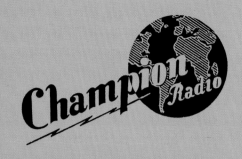

Champion Radio

S.O.S

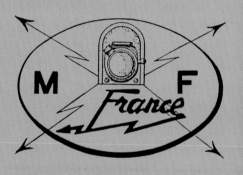

M F France

Stella Phone

Tiss-Éclair
LE CANEVAS QUI FAIT FUREUR

Bel Ekla
Marque déposée

E.M.A
LYON

Sudor

Paints & varnishes
GEORGES PEROL
PARIS • 1931

Paints for movie screens
ANDRÉ MISSEMER
PARIS • 1932

Paint
SOCIÉTÉ ANONYME VIACROZE
PARIS • 1930

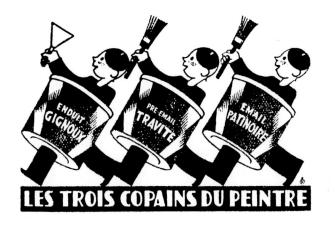

Paints & accessories
ETABLISSEMENTS GÈO GIGNOUX
SAVIGNY-SUR-ORGE • 1935

Paintbrushes
CHARLES AYRAL
PARIS • 1931

Paints & varnishes
SOCIÉTÉ BADETS ET BURETTE
TALENCE • 1931

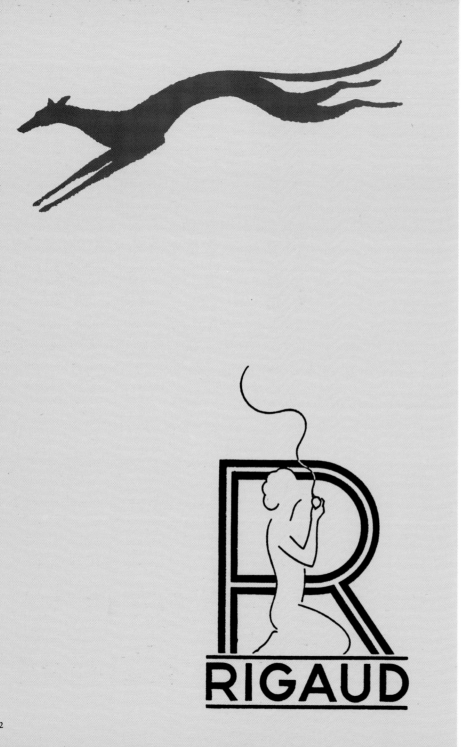

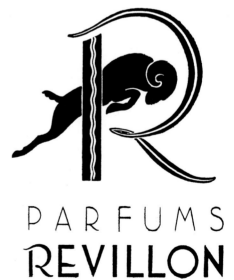

PARFUMS REVILLON

Perfumes >
PARFUMS CHÉRAMY
PARIS • 1933

Perfumes & beauty products
SOCIÉTÉ LES PARFUMS DU LIDO
PARIS • 1928

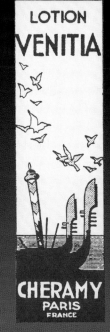

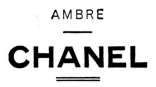

CHANEL

PARIS

Perfumes
LES PARFUMS CHANEL
NEUILLY-SUR-SEINE • 1938

Beauty products
PAUL DESTIZON
HENDAYE • 1931

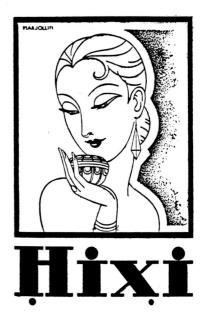

Beauty products
SOCIÉTÉ PETITHORY ET BENOZIO
PARIS • 1930

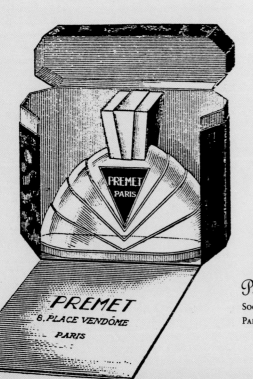

Perfumes & beauty products
SOCIÉTÉ ANONYME PREMET
PARIS • 1931

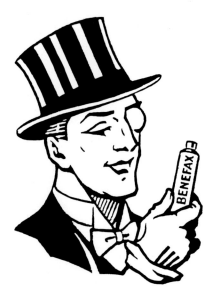

Perfumes & beauty products
LABORATORIES BENEFAX
PÉRIGUEUX • 1933

Perfumes
PARFUMS LYDÈS
COURBEVOIE • 1929

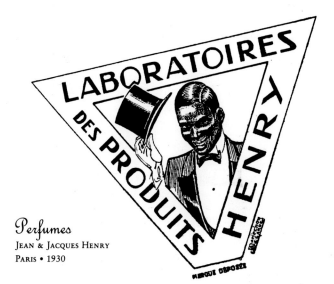

Perfumes
JEAN & JACQUES HENRY
PARIS • 1930

Sponges

VALENTIN FRITSCH
STRASBOURG • 1932

Bath products

MAXA
PARIS • 1933

Perfumes & cleansers

EMILE BEYER
STRASBOURG • 1933

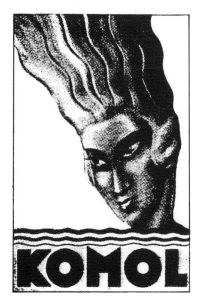

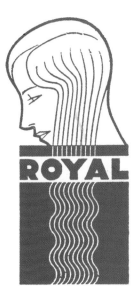

Hair products
CONTE GIROLAMO MARCELLO-GRIMANI
PARIS • 1933

Hair products & perfumes
OSCAR & J. SUTTERLIN
PARIS • 1931

Permanent wave solution
CLAUDE JOUANNY
PARIS • 1931

< *Perfumes & soaps*
MARCEL LECOQUE
BAISIEUX • 1933

Shampoo
OSCAR SUTTERLIN
PARIS • 1933

Beauty products & perfumes
SOCIÉTÉ RITZ
PARIS • 1933

Permanent wave machines >
JEAN FRIAUD
VILLEFRANCHE-SUR-SAÔNE • 1934

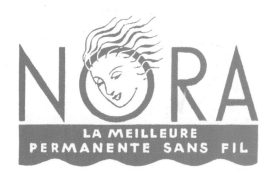

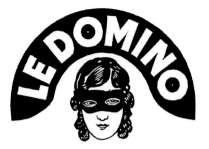

Metal polishers
PIERRE RENARD
SAINT-PAUL-EN-JAREZ • 1931

Pharmaceuticals
SOCIÉTÉ ANONYME COMMERCIALE
ET CHIMIQUE
PARIS • 1934

Medicinal water
COMPAGNIE FRANÇAISE ELECTR'EAU
DIJON • 1933

Cleansers
HERMAN KASARNOWSKI
CANNES LA BOCCA • 1932

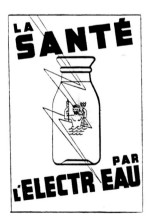

Pharmaceuticals
ANDRÉ CHAUMEAU
GRENOBLE • 1933

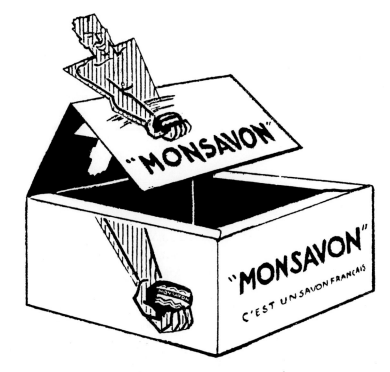

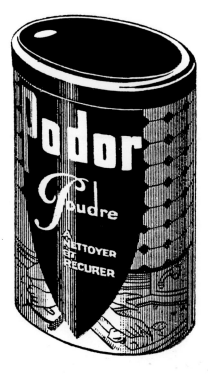

LE HOCKEY

LE SKI

Soaps & cleansers >
JEAN CORDESSE
MARSEILLE • 1934

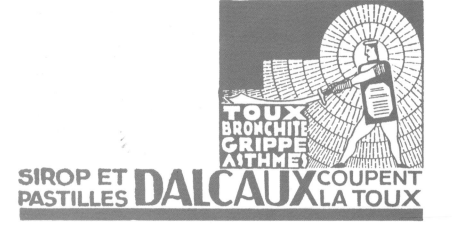

SIROP ET PASTILLES **DALCAUX** COUPENT LA TOUX

TOUX BRONCHITE GRIPPE ASTHME

MI-KI

^ *Soaps*
ERNEST HOUSSET
CLICHY • 1931

< *Cough syrup & lozenges*
RENÉ CLASSE
PARIS • 1934

L'AQUAPLANE

LE TENNIS

LE GOLF

∧ Cold-water soap

EMILE NEUSY

BORDEAUX • 1931

Glycerine >

SOCIÉTÉ GÉNÉRALE DES GLYCÉRINES

BOUSBECQUE • 1930

mutol
la merveilleuse laine d'acier

Metal polish
ETABLISSEMENTS JEAN ALLAUZEN
JOYEUSE • 1928

Household & industrial cleansers
ANDRÉ PICQUEST
ROUBAIX • 1933

Bibliography

Aarke, Nancy. *L'Art de Vivre: Decorative Arts and Design in France 1789 – 1989*. New York: The Vendome Press, 1989.

Ghozland, F. *Un Siecle de Réclames Alimentaires*. Milan: Editions Milan, 1987.

Johnson, Douglas and Madeleine. *The Age of Illusion: Art and Politics in France 1918 – 1940*. London: Thames and Hudson, 1987.

Kery, Patricia Frantz. *Art Deco Graphics*. New York: Harry N. Abrams, 1986.

Wiser, William. *The Crazy Years: Paris in the Twenties*. New York: Atheneum, 1983.

Wlassikoff, Michel. *Le Livre de La Plaque Emaillée Publicitaire*. Paris: Editions Alternatives, 1985.

Household cleansers
ALFRED HOH
STRASBOURG • 1933